# Introduction

*Our dead are never dead to us until we have forgotten them.*

George Elliot

Greyfriars Kirkyard, a place of tranquillity and a welcome refuge from modern hustle and bustle just a few steps outside its gates. In the spring the cherry blossoms spread their carpets of feathery pink petals; the summer brings the lush greens of the grass, dotted with sunbathing locals and visitors alike; autumn, with its golds and reds of the turning leaves; and finally winter, where the stones and tombs push up through the snow like the teeth of a fantastical monster ... no wonder J. K. Rowling got so much inspiration from one relatively small piece of land nestled in the Old Town of Edinburgh. However, here truth is more fascinating than fiction. Everywhere you turn there is a story to tell, and who is the storyteller? You. With this book you will learn to read the symbols on the grave markers, find out what the deceased were trying to tell those they left behind, or even what their families may have thought of them. Here the dead live on. By visiting their graves and looking at their monuments, you are helping them to be immortally remembered – just as they would have wanted. And it doesn't stop there; this book will be there to help you in any Scottish graveyard that has a tomb with a story to tell.

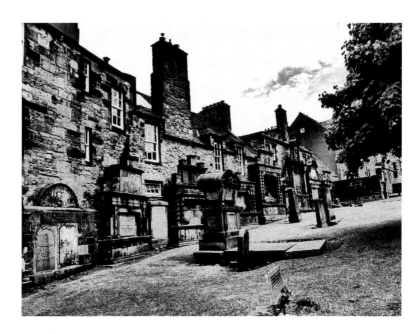

Greyfriars Graveyard, east wall.

# 1. History of the Graveyard

William Pitcairn Anderson, in his book on Edinburgh Graveyards, *Silences That Speak,* describes Greyfriars Kirkyard as being the leading burial ground in Scotland for 'the glamour it casts over the Scottish mind'. Not only for its place in history but also for the great figures of every walk of life whose final resting place is within its walls. It is the final resting place of forty-four ministers of both Old and New Greyfriars Kirks; forty-one Lord Provosts, thirty-three lawyers and senators of the College of Justice; twenty-six principals and professors of the University of Edinburgh, and even two of its founders. This is a list of but a few of the titles and professions of the people buried in Greyfriars Kirkyard who shaped and moulded Edinburgh. There are many 'ordinary' men and women who also had their great parts to play.

So where did it all begin? James I of Scotland granted the land to the friars of the Order of Francis of Assisi, known as 'Greyfriars' due to the colour of their habits. The man behind the order was born Giovanni di Pietro di Bernardone in 1182 in the Italian province of Umbria; however, after his father's return from a visit to France he decided to change his son's name to Francesco, in honour of that country. This was the man we now know as St Francis of Assisi.

As a young man, Francis joined the army after war broke out between his home town of Assisi and Perugia. Unfortunately his military career was short-lived as he was injured and captured in his first battle, spending nearly a year in captivity, passing the time helping other prisoners and offering words of comfort and encouragement. After his release Francis believed his purpose in life was to help others. While praying one day he heard God speak to him, telling him he was to repair the Church. In the beginning he interpreted this that he should repair the church building of St Damian in Assisi, but he later realised it was the Christian Church itself that needed to be repaired as it was full of selfishness and greed.

Francis decided to embrace poverty, giving away all his possessions. He dressed in a simple grey robe and walked barefoot, dedicating his life to helping people in need. He also believed nature was the mirror of God and preached to animals, seeing them as a reflection of the beauty and love of God. He founded the Order of Friars in 1209 and later, in 1212, a woman's order, the Order of Saint Clare – both for his followers who wanted to live like him.

The Franciscan monks who founded the monastery in Edinburgh followed the teachings of St Francis, vowing to a life of poverty and dedicating themselves to taking care of the poor and sick. In their gardens they grew herbs that were used to make medicines. While the friars are long gone, a few herb gardens can be found throughout the graveyard. The monks lived side by side with the city until 1560 and the Reformation. The populace, like many others across Scotland, attacked the buildings and left the monastery in ruin with

# GREYFRIARS GRAVEYARD

Charlotte Golledge

AMBERLEY

*Dedicated to the memory of William Golledge:*
*History Master, Scholar, Grandfather*

First published 2018

Amberley Publishing
The Hill, Stroud
Gloucestershire, GL5 4EP

www.amberley-books.com

Copyright © Charlotte Golledge, 2018

The right of Charlotte Golledge to be identified as the
Author of this work has been asserted in accordance
with the Copyrights, Designs and Patents Act 1988.

ISBN  978 1 4456 8818 3 (print)
ISBN  978 1 4456 8819 0 (ebook)

British Library Cataloguing in Publication Data.
A catalogue record for this book is available from the
British Library.

Origination by Amberley Publishing.
Printed in Great Britain.

# Contents

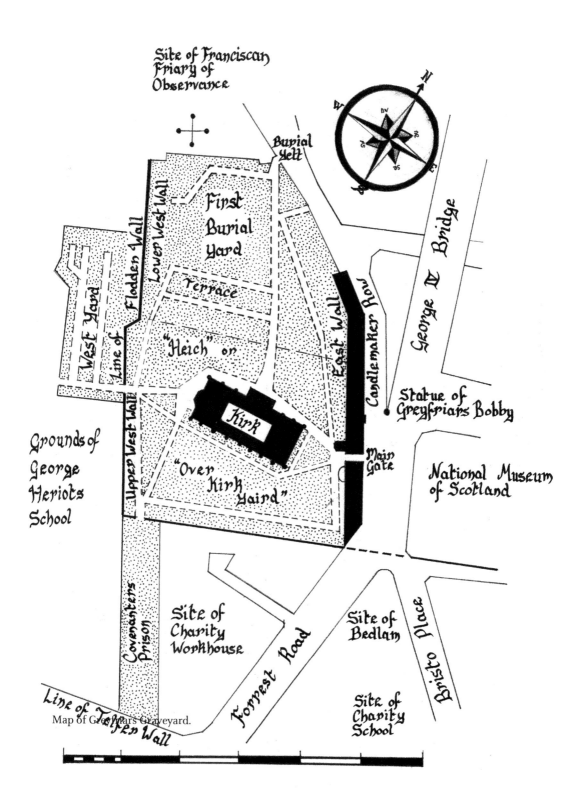

Map of Greyfriars Graveyard.

the Greyfriars fleeing to the Netherlands. In 1560, the ground reverted to the Crown and in 1562 Mary, Queen of Scots granted the lands to be used for the burial of Edinburgh's deceased as the burial ground at St Giles' Cathedral was becoming vastly over crowded. For three centuries the area around St Giles' had been the chief burial place in Edinburgh. By the mid-1500s burial was restricted to the south side of the church, sweeping down Parliament Close to the Cowgate, and the mortuary chapel founded by Walter Chepman, the city's first printer. (Sadly, the chapel is long gone, though there is an aisle within St Giles' still dedicated to Walter Chepman.) Parliament Close contained the houses and gardens of the provost and other members of government. It is perhaps due to these residents that an alternative burial ground was sought, as the risk of disease became a dangerous prospect in the now badly sanitised and overpopulated burial ground at the very heart of the city of Edinburgh.

In 1601, forty years after the burial yard had been established, the town council proposed that a new church should be built. The burial yard was deemed the most suitable area for such a church. In 1612, the congregation of Greyfriars was founded, with the completed building of Greyfriars Kirk opening in 1620, the first church to be build post-Reformation. Today you can visit the kirk, which by its official title is the Greyfriars Tolbooth and Highland Kirk, along with further monuments to those who have passed. It is a most excellent visitor centre and museum.

St Giles' former graveyard site.

Burials in the churchyard were divided into four portions, with, for the most part, a chronological order for burial. The first portion to be used was to the north of the present church, sloping down towards the Grassmarket and site of the former Greyfriars monastery. The second portion opened for general burial in 1619, though there were special cases where burial was permitted prior to this. These were the grounds to the south that, prior to the church being built, had often been hired out for pasture land and was where wapenshaws were held. The third area to open was the long strip of land in the south-west corner, known as the Covenanters Prison. Although the land was granted for burials in 1636, it wasn't until 1705 that the first plot was sold. The final portion, formerly known as Gifford's Green, is situated behind the remains of the Flodden Wall, which was once used to defend the city. The portions for burial were divided and set up in 1793, with the first burial being in 1800. All the tombs in these two latter additions belonged to the wealthier classes of Edinburgh.

The original entrance to the kirkyard is that in the north-east corner, by the Grassmarket. Constructed as an entrance in 1562, stone steps were added in 1621 replacing the earthen mound. Over the gates to this entrance were the words:

> Remember Man as Thou gaes by,
> As Thou art Now aince was I:
> As I am Now so Thou be,
> Remember Man that Thou must dee.

An additional entrance was required in 1624 and so the present main entrance was built. Unfortunately, the removal of a monument was required to do this, so the monument to Alexander Miller, master tailor to James VI of Scotland, was no more – a mere eight years after the poor man's burial.

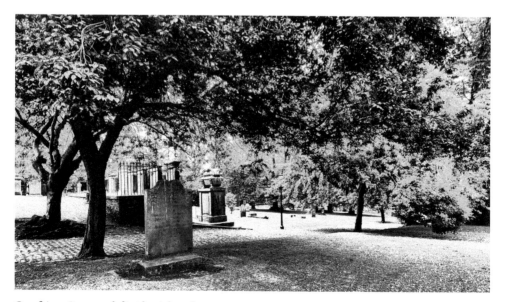

Greyfriars Graveyard, first burial yard.

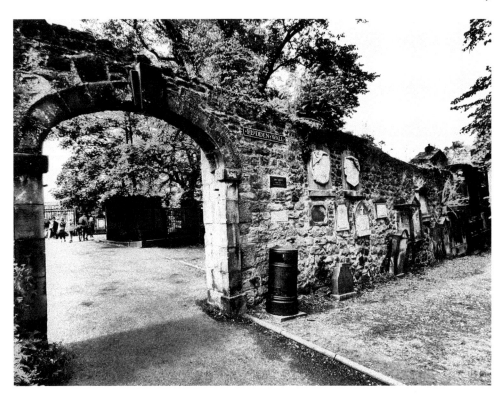

*Above*: Flodden Wall, Greyfriars.

*Right*: Main entrance to the graveyard.

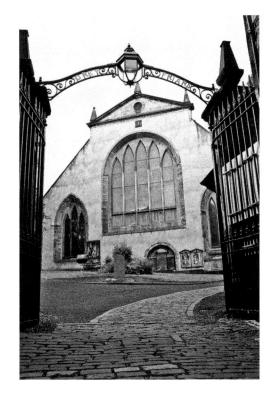

The town council wanted to keep a strict control over the burials and monuments in the graveyard. In 1591, it was ruled that no burials were to take place without the approved consent of the council. In 1603, the baillies were ordered to remove all the stones and monuments, with no further ones allowed. Councils of the seventeenth century are very like their modern counterparts with their indecisiveness and a U-turn on the decision was made in 1606, as long as an application and payment were made. In that same year John Jackson was permitted to build a monument dedicated to his father on the upper west boundary wall; it is the oldest memorial in the graveyard. Soon others were to be allowed along the walls, but no monument or marker were allowed in the central grassy areas until the eighteenth century. Payment for the building of monuments included fees that would prove support for the poor and needy in the city.

John Jackson, identified as a merchant, has a relatively impressive tomb that is often overlooked due to several grave markers carved on its front – rather primitive-looking winged souls. However, as the leading monument it deserves recognition. The Latin translation reads:

To a good citizen, thrice treasurer, John Jackson,
Called out of this life 29 May, in the year of our God 1603
And of his age 63, being climacteric in token of his love
And gratitude, his only son caused this monument to be built.

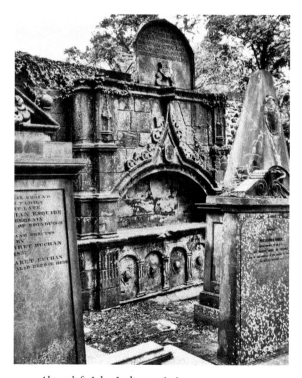
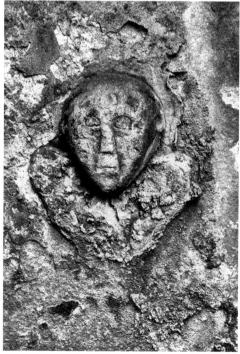

*Above left*: John Jackson, 1606.

*Above right*: A primitive winged soul.

Numerous as the monuments in Greyfriars are, no memorial exists for a great many historically important people in the kirkyard. Where there is a marker, erected years later, they are not always over or even near the person's remains and due to the passage of time the exact location may become lost. In fact, there are relatively few markers in comparison to the number of relics beneath the earth. Greyfriars is considered to be one of the most densely populated areas in Scotland for the deceased. The less wealthy would often be buried in the central areas of the kirkyard with no marker, while it is the wealthy who inhabit most of the areas near the walls. For nearly 140 years burials in Greyfriars has been prohibited, unless in exceptional circumstances.

## The Covenanters

The Covenanters hold an extremely important part of Scotland's history, with Greyfriars at their centre stage for two very different circumstances. First, however, a bit of background that is not Greyfriars related is needed.

Charles I (1600–49), the last monarch to be born in Scotland, was the second son of James VI of Scotland and I of England and Anne of Denmark. After the death of his older brother Henry, Charles became heir apparent. In 1625, his father died, making Charles king. Having spent most of his life in England, he witnessed his father rule over the English people and become established as head of the Church of England. Charles believed that he was given his position as king by God and in turn believed in the divine right of kings. As such, Charles ordered his subjects to do whatever he pleased and generally did not consult others or ask for advice. When Charles began to make decisions on the Scottish Church without consulting the General Assembly, mutterings of discontent began. He wanted to bring the Church of Scotland more in line with the Church of England, ordering changes to the way services were performed such as kneeling at communion, the clothes ministers should wear and appointing bishops to the Scottish Privy Council.

In 1637, the king pushed his Scottish subjects too far when he had a new common prayer book written with William Laud, the Archbishop of Canterbury. This book was to be used in all church services and Charles was so insistent that he would be obeyed that he declared that any opposition would be considered treason. When the first reading of the prayer book took place in Edinburgh on Sunday 23 July 1637, all hell broke loose in churches throughout the town. With an uncontrollable anger at the papistical sermon, the people started to riot within the churches, throwing stools and books. It is said that the minister at Greyfriars was chased out of his church by a mob of angry women!

In Edinburgh hundreds of nobles, ministers and burgesses were gathering petitions signed by a growing number of people. A group of representatives were elected to persuade the king to remove the bishops from the Privy Council and withdraw the new religious guidelines and liturgy. This group effectively became an alternative government, gaining the name 'The Tables'. This group chose Alexander Henderson, a clergyman, and Archibald Johnston of Warriston to produce a document uniting all the people who were opposing Charles' highly unpopular decisions. This document was the National Covenant.

The National Covenant referred to Acts of Parliament and legal agreements made by James VI/I in which the monarch agreed to uphold the Presbyterian Church and the laws of Scotland. It also rejected the new policies that Charles had introduced in both religion

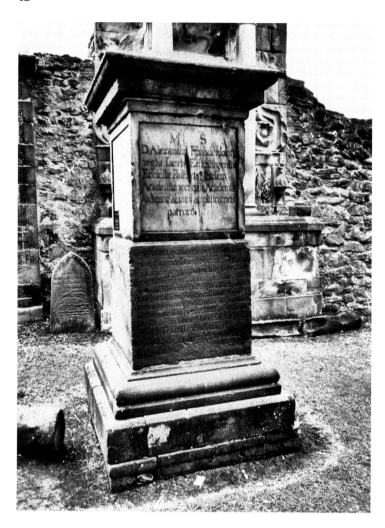

Alexander
Henderson.

and government, yet those signing the National Covenant stated they were still loyal subjects to the king. On 28 February 1638 many of the nobility gathered at Greyfriars Kirk to sign the Covenant. The following day ministers and their representatives of the burghs added their names. Copies were then made and taken countrywide to sign, but many in the Highlands did not wish to do so. The following year the rebellion led to war between Charles and the Covenanters, which in turn sparked off the English Civil War.

The conflict of the struggle between the Covenanters and the Crown (including the intermediate years when there was no monarch) lasted from 1638, when the National Covenant was created, only coming to an end in 1690 when William III (of Orange) established a new Church of Scotland that was considered acceptable to most Covenanters.

The next time Greyfriars was central to the Covenanters' story was 1679. With the restoration of Charles II, the revival of episcopacy in Scotland was once more enforced there. This led to great anger and what became known as 'The Killing Times'. James Guthrie, a Presbyterian minister, was executed in 1661 for criticising Charles II's religious

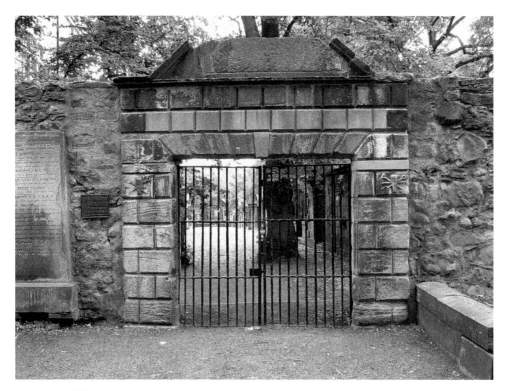

Covenanters' Prison gate.

orders, making him the first of many martyrs whose remains were to be laid to rest in Greyfriars. It was the Battle of Bothwell Bridge on 22 June 1679 that brought the Covenanters back to Greyfriars. After the battle more than a thousand prisoners were taken to the exposed southern area of the kirkyard – part of the original area that is now known as the Covenanters' Prison. Here they were subjected to harsh outdoor conditions for over five months: from the heat of Scottish summer, the dampness of autumn through to the freezing cold of early winter. The daily ration supplied to each prisoner by the episcopal ruling Privy Council was one penny loaf a day. To prevent any chance of escape, no male citizens were permitted to approach the kirkyard, though through an act of mercy women accompanied by a guard were allowed to bring nourishment and comfort to loved ones at specified times of the day. Alas, even with the allowance of such a small act of kindness, many succumbed to hunger and exposure to the unpredictable Scottish weather.

There was pity shown by one noble who was not of the Covenanter movement: the Duke of Monmouth, eldest illegitimate son of Charles II, and his mistress Lucy Walter. Monmouth obtained a Privy Council order offering to liberate a majority of the prisoners if they signed a bond forbidding them to ever take up arms against the king or Crown. It is claimed that several hundred agreed. These pardons and those who had succumbed to the elements, left the final total of prisoners at 380. On 15 November 1679 these remaining prisoners were marched through the streets of Edinburgh down to Leith and

loaded aboard a ship called *The Crown* to be transported to the colonies. Unfortunately a violent storm lashed the ship, wrecking it on the rocks near Deerness in Orkney, killing them all. A 10-meter brick monument is near the site of the wreck on the mainland that is dedicated to them.

Over the years the Covenanter movement took a few dramatic changes in direction. Starting off as a campaign of peaceful protest, it soon became war. The Covenanters controlled Scotland for a few years, but when this government collapsed they were persecuted by the king. The Covenanters are commemorated across Scotland with various memorials. The Martyrs' Monument in Greyfriars was built in 1706 and is dedicated to the martyred souls who died for their beliefs.

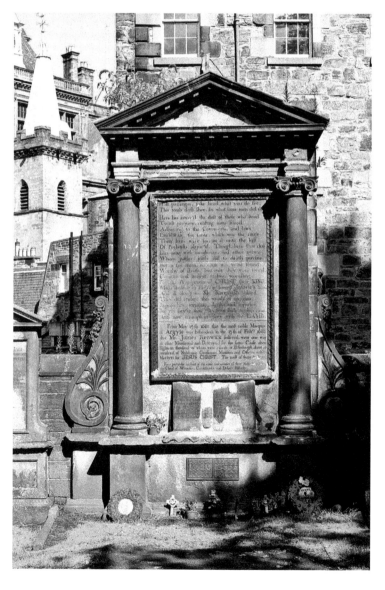

Martyrs' Monument.

# 2. Types of Graveyard Monuments within Greyfriars

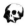

The type of grave marker used can reveal a lot about the person it is intended for, even without the additional carving or words it may have to adorn it. Although fashion of the times has a lot to do with the choice of marker, there are still some spectacular examples of individuality in Greyfriars where the person (or the deceased's family) has firmly made a mark for the final statement of their life.

*Burial Enclosure*
Burial enclosures are defined as being burial grounds specifically for one or more graves, usually from the same family. They may be enclosed by walls, railings or a combination of both. The area within the Covenanters' Prison is primarily of high-walled burial enclosures and mausoleums. Unlike mausoleums, these enclosures do not have roofs and resemble small walled gardens or yards rather than buildings. There are a few low-walled enclosures, often missing the railings that would have been in addition to the masonry throughout the kirkyard. Luckily there are still some railings that escaped removal during the 1940s, when many burial grounds had them removed for the production of steel during the war effort.

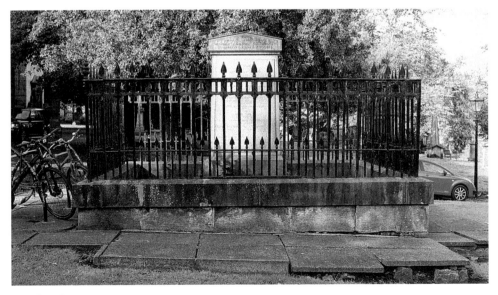

Burial enclosure.

## Cast-Iron Grave Marker

Unfortunately, there are only two examples of freestanding metal markers within Greyfriars. The first can be seen near the east wall and is dedicated to George Buchanan. This was a memorial plaque erected in the nineteenth century and is in an area likely to be his final burial place. He is one of a select number of people who have more than one marker within the kirkyard.

The second example can be seen in front of Elizabeth Paton's magnificent mural monument. This design is typical of the nineteenth century as they were mass-produced; near identical ones can be seen in other burial grounds across Scotland. They are now quite rare, however, and often in an advanced state of deterioration. More often than not the inscription is impossible to read, like this one.

## Coped Stone

This marker looks almost like a 3D flat stone. It has a rectangular base, like a flat stone, however it has a raised panel that slopes down to the corners. These markers are often mounted on pedestals, but they may also be flat on the ground.

*Above left*: Iron marker.

*Above right*: Coped stone.

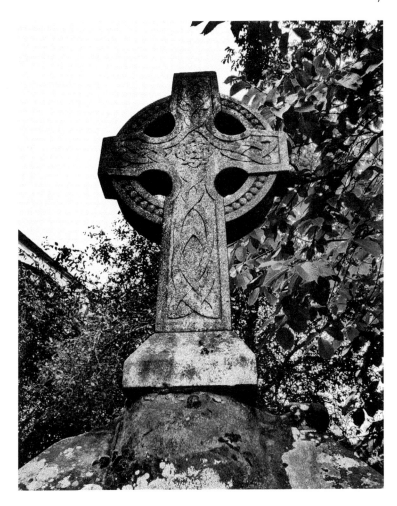

Cross.

*Cross*

After the Reformation crosses were rarely used as a grave marker as it was considered to be a papist symbol. By the nineteenth century they had made a revival, but despite this there are only a few nice examples in Greyfriars. To see a variety of crosses in Edinburgh, a visit to Warriston Cemetery is needed.

*Flat Stones*

These stones often cover the ground over where the deceased has been buried and are generally the same size as the person they are laid for. The exception for this is if there are stones that have already been laid in a family plot as the size will be uniformed to match those already there.

There are usually marginal inscriptions on flat stones as well as a central inscription, a carving of the family heraldic device or a symbol of mortality. There can also sometimes be an combination of two of these, or even all three. These stones can also be referred to as recumbent slabs, ledgers or thowch stanes.

Flat stone.

## Headstone and Footstones

Without a doubt, the headstone is the most recognisable type of burial marker; they are identifiable worldwide. The original custom to mark a grave was to use both a headstone and footstone together. The function of these was to mark a burial plot during an age prior to the detailed organisation of burial grounds. There are a number of headstones and footstones throughout Greyfriars bearing initials. Most of these are singular as others have sunk or been removed over time.

Headstones as we know them now started to be erected in Scottish graveyards in the early seventh century and are considered to be adapted versions of the Greek and Roman stele. The primary use of the stele was to commemorate a person – often after death – but they were also used to give information and mark property boundaries.

The headstone inscription can give us a wealth of information: not only who the person was and when they were born or died, but also what others thought of them, who had the stone erected or even have some lines of verse. Headstones can be highly decorated or can be quite plain and simple. One such headstone in the graveyard, by the north wall, is a plain granite stone that simply reads: 'IN MEMORY OF THE KINDNESS AND AFFECTION OF A DEAR FRIEND'.

## Mausoleum

These spectacular burial markers are small buildings to house the deceased. The name derives from King Mausoleus' great monument at Halicarnassus. They are often impressive either in size or decoration and more often than not the first person to be laid to rest in one will have had it built in his or her lifetime. It was an additional way to show someone's standing in the community and wealth.

*Above*: Footstone.

*Below left*: Headstone.

*Below right*: Mausoleum.

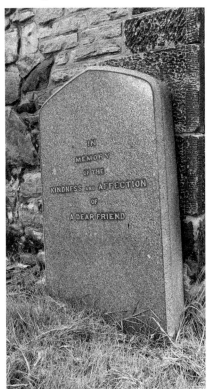

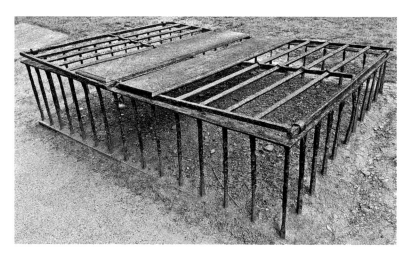

Mort safe.

## Mort Safe

During the times of grave robbing, families who wanted to keep their loved ones safe would use a mort safe. The examples seen in Greyfriars include not only the metal cages but also as bars over the top of a burial enclosure. These were designed to create a cumbersome deterrent for the resurrectionists who would 'acquire' bodies for the anatomy schools. Although technically not a grave marker used for remembrance, they hold an important place in the history of Scotland's graveyards and tell a powerful story of protection for a loved one.

## Mural Monument

Greyfriars is the home to Scotland's most spectacular mural monuments and are the basis for this book being written. Along the east and west wall of the original burial ground in particular, there are elaborate mural monuments adorned with all manner of carvings and symbols. The men and women who they are dedicated to may have been all but forgotten, but their deaths – if not their lives – live on, telling each generation a story available to all who wish to listen with their eyes.

When the General Assembly first banned burial in churches in 1576 they also forbade the erection of tombs in graveyards. The wealthy and the elite of Scotland were to lead by example and bury their dead out with the church; however they were not prepared to leave the graves unmarked. The designs often emulated the sort they would have once had within the church, though on a larger scale.

Some of the most striking features of the mural monuments are the wealth of carvings that adorn nearly every space of exposed stone. From symbols of mortality and immortality to floral decor and symbolism. Each mural can tell a story of the buried beneath, and half the fun for us is to discover what story they are trying to tell while admiring the beauty and craftsmanship of the stones. It is this latter part we should perhaps think of, as the men who created such beauty have slipped into obscurity since it was deemed vulgar to leave a mason's mark on a mural monument at the time. From the similarity in design and style, however, it is evident that some of the same men were employed time and time again, and while their names are long gone their craft has survived through the centuries.

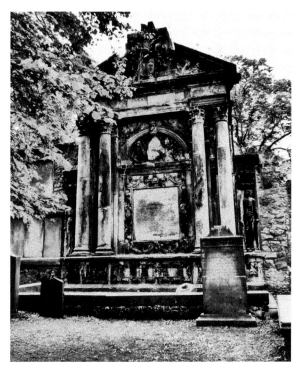
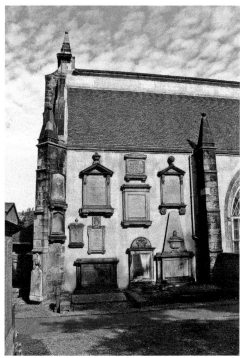

*Above left*: Mural monument.

*Above right*: Mural tablets on the side of the church.

### Mural Tablet

These are built into a church wall or fixed upon it. They are usually quite plain, simply bearing an inscription, however there are some on Greyfriars Kirk that include quite a bit of ornamentation.

### Obelisk

This kind of monument has a tapering shaft of squared stone, topped with a pyramid shape. These were erected for people deemed to be of great importance. There are a few of them in Greyfriars, particularly in the south yard, however there is a fine example that dominates the skyline to the south of Princes Street at the Old Calton Burial Ground. This is the burial marker for the great Scottish philosopher David Hume, whose statue can be seen on the Royal Mile.

### Pedestal Tomb

These are tall grave markers, often freestanding, though they can also be seen against walls. They can be of varying shapes: square, rectangular, polygonal or even circular. At times the pedestal may be surmounted with a decoration such as an urn, cross or a figure such as an angel or weeper. Unfortunately, through the passage of time many of these extra items of decor have been removed or lost.

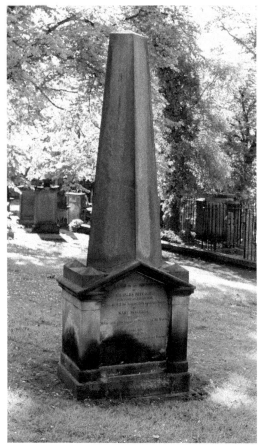

*Above left*: Obelisk.

*Above right*: Pedestal tomb.

## Sarcophagus

This is a classical-style marker and seen in burial grounds across Britain. It often looks like a casket or is in an altar-type shape. There is a fine example near the east wall belonging to George Hunter, which is noted as having been erected by his three sisters.

## Table Stone

This striking example of a grave marker can be identified as a flat stone placed upon supports to give the appearance of a table. There is no uniformed number of supports, nor is there a uniformed height. The pedestals can be of various shapes and may be decorated. Some examples of table stone support have the ends filled in, giving extra support at either end. These sorts of table stones generally survive the test of time better than their counterparts that don't have the same added stability. There are a few beautiful examples within Greyfriars that, for the most part, have survived the years pretty much intact.

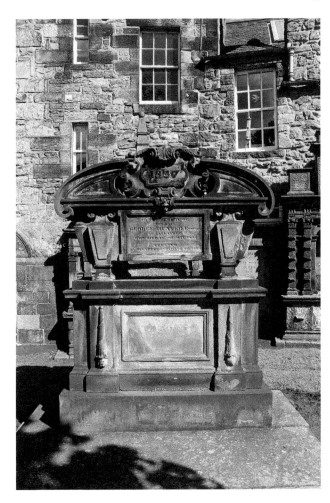

*Right*: Sarcophagus.

*Below*: Table stone.

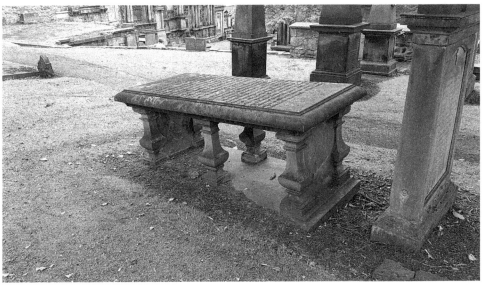

# 3. Symbolism on the Monuments

Greyfriars is home to many spectacular post-Reformation monuments, showing us decisive trends in monuments over time and also, perhaps more importantly, what went on them, especially in the seventeenth and eighteenth centuries. Post-Reformation symbolism on monuments followed a similar pattern nationwide. While the appearance depends on the skills of the mason (and the wealth of the person paying for it) the meanings were the same. The three main themes that they followed were mortality, immortality through resurrection and the means of salvation.

## Emblems of Mortality

Emblems of mortality are to remind us that death will come to us all. The message is that time spent in our earthly body should be spent well through living a moral and good life, for when the time comes – and it comes for us all – judgement will be passed upon the soul.

### Coffin

As the receptacle to house the earthly remains the coffin is an important part of death and the burial process, and is easily recognisable. During the seventeenth century a depiction of two crossed coffins was a common choice for decoration. By the eighteenth century a single coffin became favoured instead. These single-coffin designs are sometimes depicted with the spokes used to carry the coffin in traditional walking funerals.

### Deathbed

An interesting deathbed scene at Greyfriars can be found on the Carstares tomb on the upper-west wall of the graveyard. In this instance, it is portrayed as a skeleton (so there can be no mistaking that the person is at death's door) lying in a shroud in a box. This indicates the

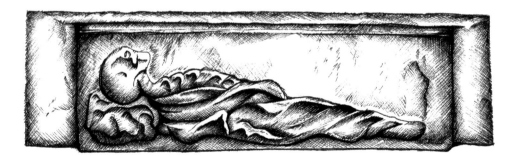

Deathbed scene.

final rest for the earthly body that will wait behind until the Day of Judgement. Other deathbed scenes are shown as a shrouded corpse lying in a box or on a bed, sometimes with curtains.

## Death Heid/Death's Head

This is one of the most common symbols seen throughout the kirkyard by far. Popular on tombs of the eighteenth and nineteenth centuries, there are hundreds to be seen within the kirkyard in different guises: full face, without the bottom jaw, facing front, partial profile, with crossed bones below or behind, or the sexton's tools in place of the bones and the winged skull. There are many fine examples to be seen and quite often it is easy to identify which tombs have been carved by the same mason. This symbol was used to represent death and remind the viewer that death comes to us all. The addition of the words '*memento mori*' on later examples translates as 'Remember that you must die'.

The popular – yet incorrect – theory of the use of the skull and bones is that the deceased was a plague victim or a pirate! However, one possible explanation for the use of a skull and bones depicted on medieval monuments stems from the crusades, when knights or persons of note died in distant lands and the need for the body to be transported back home. *Mos Tentonicus* was a post-mortem funerary process that removed the flesh from the bones and enabled the hygienic means for the transportation of the bones for proper burial at home.

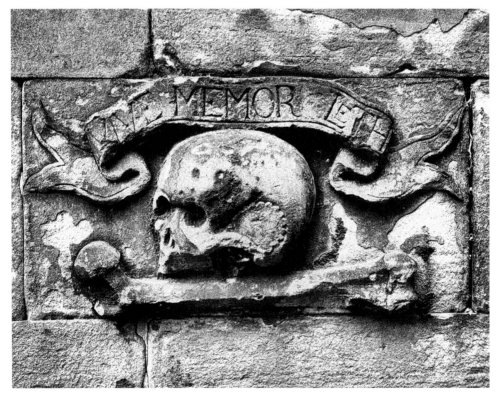

A *memento mori*.

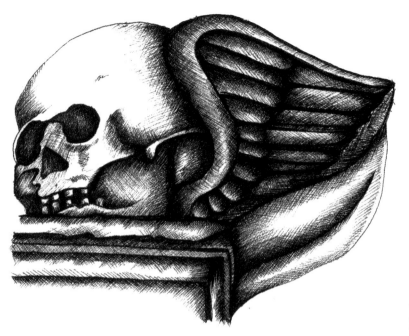

Winged death head.

## Deid Bell/Mort Bell

The traditional method of calling people to a funeral would be the ringing of the deid bell, or mort bell, and the verbal bidding of the bellman. It would then be rung again at the head of a funeral procession on the way to the kirkyard for the burial of the deceased. In Greyfriars it is commonly depicted as a handbell in the process of being rung, though there are also carvings of bell heads without handles.

## Father Time

There are several examples of Father Time within the kirkyard. One stance he adopts is of the bearded man, seated in a typical pose with his elbow resting on an hour glass and his scythe by his side as if he has just finished his work. Other examples show him upright in the process of harvesting time. There is even a Father Time who looks to be dressed in kilt! The wording *Tempus Edax Rerum* may also be seen translated: 'Time, devourer of all things'. He is often seen in the company of the King of Terrors, working together to bring an individual's life to its closing.

## Green Man

The Green Man is a popular choice of carving throughout Greyfriars. It is sometimes used as a central theme, while in other instances makes a sneaky appearance from within a carved mural or decorative edging of a tomb – such as a scroll. Traditionally, the Green Man has a humanoid appearance, often with greenery sprouting from forehead, ears, nose and/or mouth. A popular carving on ecclesiastical buildings up to the eighteenth century, its origins are said to have come from the pagan leaf mask, which was in turn then used by the Romans.

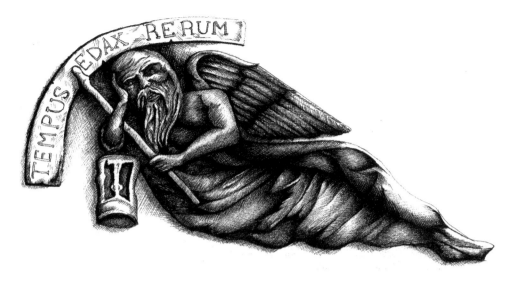

Father Time.

However, for the majority in Greyfriars, the green men, while still mostly humanoid, also take on a feline or beast-like appearance – almost that of a gargoyle in some instances. The features are often quite old-looking with evident wrinkles carved and very little greenery to be seen. While the Green Man represents new life that comes from death, just as nature springs forth from the harshness of winter, in Scottish graveyards it also represents the decaying of the flesh before new life can be created – hence the lack of greenery and the reason why it is considered a symbol of mortality.

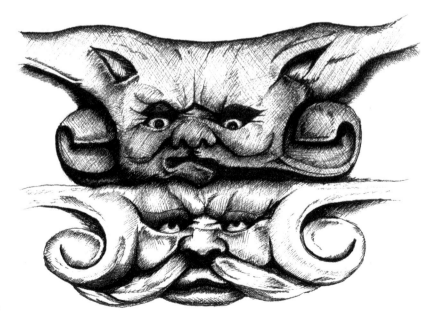

Green Man.

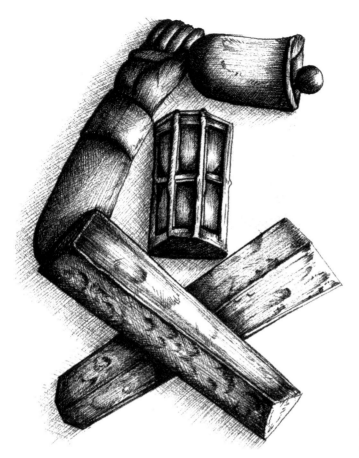

From top to bottom:
deid bell, hourglass and
crossed coffins.

## Hourglass

The symbol of the hourglass clearly represents the passing of time towards the end of one's life. An hourglass on its side indicates that time has stopped for the person within the grave. The winged hourglass symbolises that time flies swiftly and death comes to us all eventually. The hourglass was an easily identifiable item to those who attended church, counting down the minutes of a sermon. It was not unheard of for people being buried with an hourglass within their coffin.

## King of Terrors

The symbolism of the King of Terrors is one of the least subtle symbols of mortality. He is the personification of death. Portrayed as a skeleton, stripped of flesh and grinning out macabrely on mortal man, he is often holding a weapon of death – the most recognisable is the scythe, but there is also the lance, the axe, the dark and the bow and arrow.

The King of Terrors is mentioned in the Bible: 'His confidence shall be routed out of his tabernacle and it shall bring him to the king of terrors.' (Job 18: 14.) Here, Job's friend Bildad explains how God causes the wicked to suffer as they are guilty of sin.

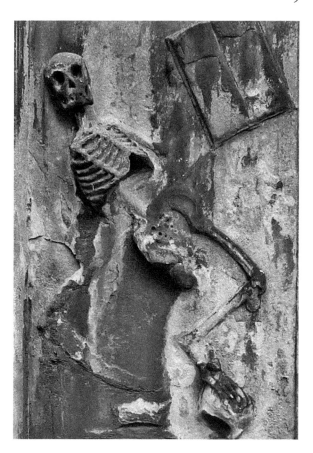

King of Terrors.

While there are many examples of the King of Terrors throughout the kirkyard (especially on the west wall's seventeenth-century mural stones), the largest depiction – almost life-sized – greets visitors from the east wall of the church. It is on James Borthwick's monument, standing alone as a fine example where he appears to be almost gleefully dancing. Although eroded with time, his scythe is still recognisable, looking as though he is weighing up and judging all who pass by.

### Scales
Scales will often be depicted with one side higher than the other, representing the balance of life is over. The scales are the symbol of St Michael, the archangel responsible for helping souls in the hour of their death, who is sometimes shown weighing souls to judge their worth. Scales can also represent the occupation of a trader; if this is the case they will be more evenly balanced. Scales may also be seen held by the virtue Justice.

### Sexton's Tools
These are the tools used by the sexton to dig the grave for the deceased and include the turf cutter, the spade and the pick. The tools are often seen as a pair that are crossed and at times are used in addition to the death heid.

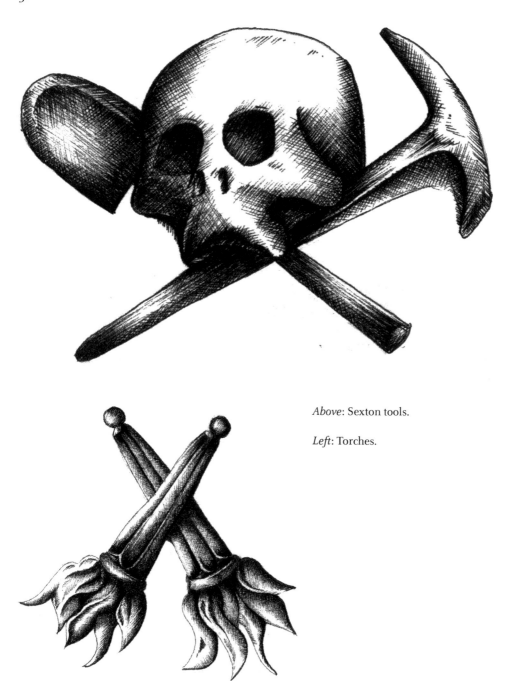

*Above*: Sexton tools.

*Left*: Torches.

## Torches

During the seventeenth century night-time funerals were not uncommon and torches were used to light the way. As such, they are recognisable as a funerary symbol, making them primarily a symbol of mortality; however, they can also represent

immortality. To decipher what they are depicting, the placement of the torches needs to be established: if the torch is inverted and extinguished it is a symbol of mortality; when inverted and flaming it indicates that the soul, represented by the flame, continues after death. Technically the latter is also a symbol of mortality, as the emphasis is on the moment of death. When the torch is shown as upright and flaming this symbolises eternal life and is a symbol of immortality. (*See* also 'lamp' in 'Emblems of Immortality'.)

## Emblems of Immortality

### Angel of the Resurrection

There are many angels of the resurrection seen throughout the graveyard. Sadly, most have lost their most defining accessory over the years: their trumpets. These humanoid figures are usually clad in loose-fitting robes and depicted as either flying through the air, blowing on their trumpets or standing holding their instrument, getting ready for the job ahead. They can also be seen depicted as naked and cherub-like, but if the trumpet is present on their person they are indeed angels of the resurrection.

Angel of the resurrection.

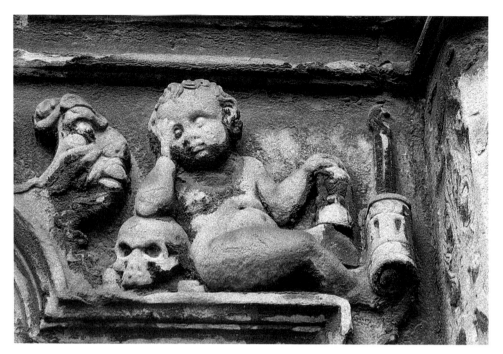

Cherub.

### Cherub

The use of the cherub in funeral art in Scotland represents the soul leaving the body at the time of death – casting off old age, illness or pain and ready for eternal life. The cherub may be used in place of a winged soul or even in addition. They may be depicted with or without wings and may even be shown making up part of a trio with the King of Terrors and Father Time.

### Crown

The crown is used to represent the crown of righteousness. It is also a symbol of leadership and distinction, in addition to being a symbol of royalty. When Paul's end was near, when he was to be martyred, he said the following:

> For I am now ready to be offered, and the time of departure is at hand. I have fought a good fight, I have finished my course, I have kept the faith. Henceforth there is laid up for me a crown of righteousness, which the Lord, the righteous judge, shall give me at that day and not to me only, but unto all them also that love his appearing.
>
> Timothy 4: 6–8

### The Fallen Tower

The fallen tower is not a common symbol, and in Greyfriars it appears only once – prominently on the Coittes tomb. It is a symbol of resurrection, although to the casual observer it would appear to be a symbol of mortality, as life cut short. However, the tower

Fallen tower.

bears a strong connection to the Tower of Babel, as told in Genesis 11: 1–9. The Towel of Babel was built by man and was meant to reach up to Heaven, but God dispersed men far and wide, giving them different languages so they could not conspire to do such a thing again. The tower was not the way to reach Heaven, so the fallen tower shows that only by death and then resurrection can Heaven be reached.

### Heart
The heart, when used as a symbol of immortality, signifies divine love. The love from God will not be extinguished by death. There are also cases where the heart is used to represent the soul.

### Lamp
The lamp is a symbol that is universally recognised as God. 'For though art my lamb, O'Lord and the Lord will lighten my darkness.' (Samael 2: 22–29.)

It is a symbol of immortality as God's light will shine on the soul eternally and light the way to Heaven. With this in mind, the lamp is also a symbol of holiness and wisdom.

### The Radiance or the Glory of God
This can be depicted in various ways, from a simple sunburst to a full scene with the sun shining out of clouds accompanied by sun rays and trumpets.

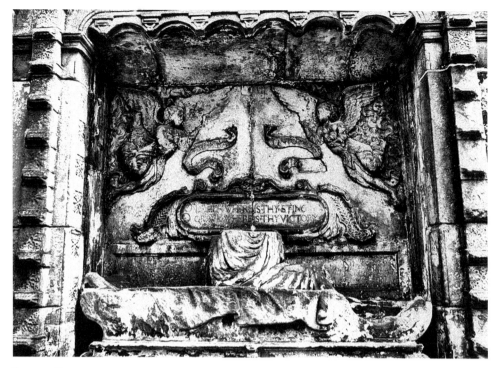

Resurrection scene.

### Resurrection Scene

The resurrection scene will typically show a deathbed with an occupant. Greyfriars is home to one of the most spectacular resurrection scenes to be found anywhere in Scotland. The Naysmyth tomb on the east wall shows the deathbed of John Naysmyth. We see folds of fabric covering his lower half and we do not see the soul of the upper half as he sits up, ready for eternal life. Above him are two angels of the resurrection.

### Trumpet

Although often seen with an angel of the resurrection, they are also depicted as an emblem of immortality on their own, symbolising resurrection and victory. The form of the trumpet can vary from post horns to natural trumpets.

### Winged Soul

The winged soul is the most common symbol of immortality to be found in the kirkyard, whether it be a central focus of the design or used as multiple decorations along the upper detail of a mural monument. The soul is commonly depicted as a neutral-gendered face, though the face often takes on the form of a cherub or angel with wings, usually bird-like and feathered. This represents the deceased person's soul leaving the body at death and ascending; the body will rise to join it on the Day of Judgement. While often shown as just a head, it may also be depicted with a frill or feathers below the neck, though it is not unheard of for the upper torso to also be present.

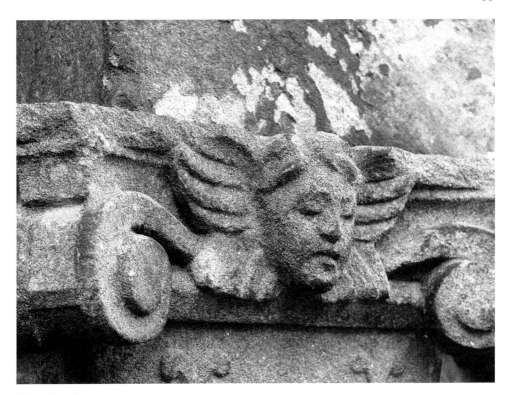

Winged soul.

## Moral Emblems

A number of tombs use a human female form to illustrate moral messages. The use of the classical Greek and Roman world for imagery was also quite typical of the early to mid-seventeenth century.

### The Seven Virtues: Cardinal Virtues

The cardinal virtues are the first four listed in the Bible, which can be found in Wisdom of Solomon 8: 7: 'She [Wisdom] teaches Temperance, and Prudence, and Justice and Fortitude, which as such things as men can have nothing more profitable in life.'

The first is prudence. This virtue requires us to seek council as it is easy to fall into error. Prudence is personified as a woman with two faces. Shown with a helmet on her head she holds a looking glass in her left hand, which symbolises the bidding that we should look at ourselves and acknowledge the wisdom it will bring.

The second is justice. Justice is blind and justice is equal, no matter who is affected. Justice is personified as a virginal woman. She is blind so is depicted blindfolded or staring straight ahead. In her hand she holds the scales of Justice, balanced at an equal weight.

The third is fortitude. Fortitude is the only one of the cardinal virtues that can also be a gift from the Holy Spirit, allowing us to rise above our natural fears. This virtue is personified as a female warrior holding a club and leaning on a pillar.

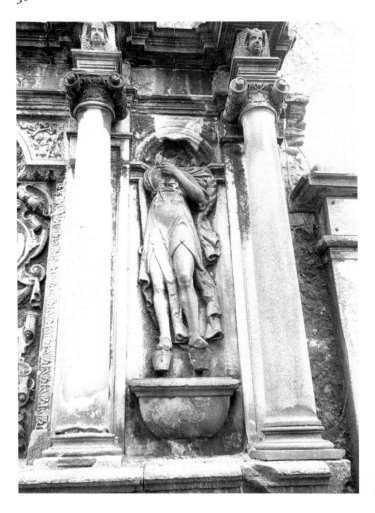

Personification of Justice, sadly missing her head.

The fourth is temperance. Temperance attempts to keep us from excess. This virtue is personified as a gentle woman, but she can often be hard to identify as what she carries can vary. She has been depicted with a bridal in one hand and the stay of a clock in another to show self-control. She may also be depicted with a water jug, though this is usually on the tomb of a prohibitionist.

### The Seven Virtues: Theological Virtues
The theological virtues are gifts from the Holy Spirit and cannot be learnt.

The first is faith – the gift through morally right actions. This is personified as a woman holding a cross, candle or chalice.

The second is hope – the gift granting eternal life for the soul. Hope is personified as a woman, traditionally with wings; however, when present on a tomb she often does not have her wings so she is not confused with an angel. She is, however, always seen with an anchor.

The third is charity. The gift of charity or love is seen as the greatest virtue of all. Charity is personified as a woman, nearly always with a baby present at her breast. She may also

be seen wearing a flaming crown. The flame represents that charity is never idle. God is both charity's origin and its object.

### Other Personifications of Moral Emblems in Greyfriars

Constancy: a woman seen to be embracing a pillar. The pillar is strength and she represents the quality of being dependable and never-changing.

Democracy: a woman with a garland of elm and vine around her head. In one hand is a pomegranate and in the other a handful of serpents. The pomegranate represents the coming together of many under one body. The vine, elm and serpents all represent union. The serpents, twisting and constantly moving, are held together so no single one can aspire ahead of the others.

Religion: a veiled woman holding a book. Traditionally she would have an elephant by her side – the emblem of religion. The veil represents that she has been forever secret, and the book is the Book of Scripture.

## Animals

While an animal may have a personal meaning to an individual or a family (such as on a family crest) there are known meanings behind the choice of an animal on a tomb or marker.

### Crane

A symbol of loyalty and vigilance. The crane will watch over the departed, standing silently and respectfully as it guards the grave.

### Dove

It is a universally recognisable symbol of peace and purity. It is also a symbol of the Holy Ghost. Saints who have a dove attributed to them include St Agnes, St Gregory, St Scholastica and St Teresa of Avila.

### Horse

When the horse is used as a symbol the meanings are so varied it can be hard to tell what is being portrayed, unless it is part of a scene that may give more clues. The horse is an animal of strength, power and freedom, and is both domesticated and wild. The ancient Greeks used horses at their funerals as they were said to be the bringers of change in life, whether that be birth or death. They are animals of contradictions. The symbol is commonly used in heraldry, where it symbolises the readiness to serve the Crown as well as being a representation of speed, intelligence and masculinity.

### Lamb

Agnus Dei is also known as the Lamb of God. The lamb is usually shown with a cross or banner that looks like a flag. It represents the Passion of Christ. It is often used to represent innocence and may be found on the grave of a child. In John 1: 29, Christ himself is the Lamb of God: 'The next day John seeth Jesus coming unto him, and saith Behold the Lamb of God, which taketh away the sin of the world.'

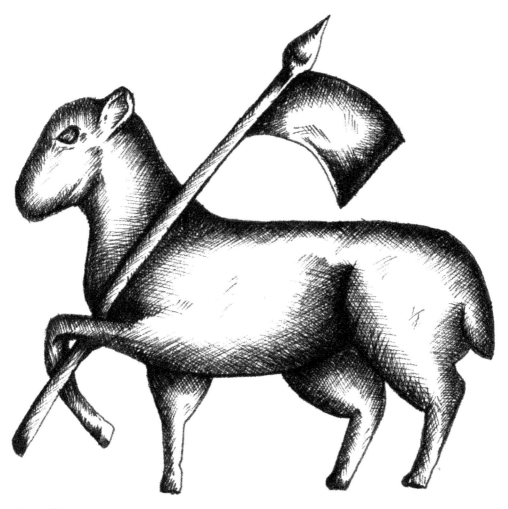

Agnus Dei.

### Lion
Courage and strength are the main characteristics of this symbol. Lions are often seen as a protector of the dead in burial grounds. The winged lion is the emblem of St Mark. When used as decoration on a burial marker it represents the traits of that person in life: strength, courage and a majestic presence.

### Peacock
There are a few images of peacocks throughout the kirkyard. In most cases it may just be seen as the head, hidden among many other carvings. There is a full example of the side profile of two peacocks on the mural monument of James Murray of Deuchar's on the east wall. Though it may not be identifiable to our modern eyes at first glance, the peacock is considered a symbol of immortality.

Peacock.

## Scallop

The scallop shell has been used for decoration since Roman times. In biblical terms the scallop shell is most associated with the Apostle James. James is often depicted in art as a pilgrim and the scallop shell can be seen on his clothing. As well as symbolising a journey of pilgrimage it is also represents rebirth and baptism, making it a symbol of immortality. Shells are also popular additions to graves as they show that someone has travelled to visit the departed, indicating that they are still remembered. On a practical note, during times of bodysnatching and the so-called 'resurrection men', shells and flowers would be left on freshly buried graves to show if a grave had been disturbed.

## Serpent or Snake

The serpent can be either a symbol of immortality or mortality, depending on how it is depicted. When a snake is shown with its tail in its mouth, making a ring, then it is the symbol for immortality and the universe – ouroboros. All is without ending and everlasting.

The caduceus is a wand with a single snake or two snakes. It was the wand carried first by the Greek god Hermes and later by the Roman god Mercury, the messenger to the gods and the guide for the dead. It is also the recognised emblem for the College of Physicians.

The serpent is also the symbol of sin and death, making it a symbol of mortality too. Snakes are often thought of as being sly, cold-blooded and poisonous, giving them a negative reputation. When wrapped around another object, such as an urn, it indicates that death has come. If the snake is accompanied by an apple in its carved scene, it represents sin.

*Left*: Caduceus.

*Below*: Snake.

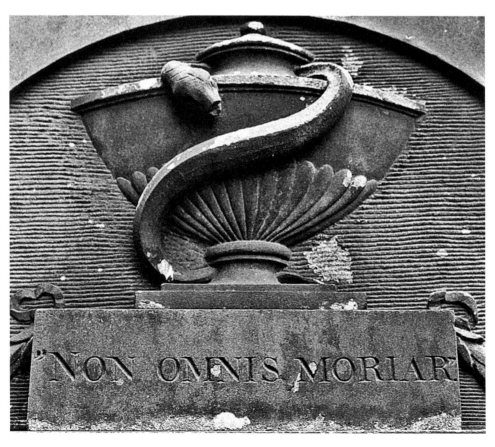

"NON OMNIS MORIAR

Snail.

## Snail

There is only one known example of a snail. As you walk up the stairs near the west wall to the terrace, by the bottom step you will see a number of stones that were moved from the Trinity Church when it was demolished.

A snail is considered to be a symbol of Christ's resurrection, as the snail will seal itself within its shell only to emerge after the harshness of winter.

## Stag or Hart

A noble symbol of piety and religious aspiration. Edinburgh in particular holds a special bond with the hart. The legend of David I and the hart dates from 1127. The standard version states that the king was hunting in the forest to the east of the city during the Feast of the Cross when a hart charged his horse, throwing him to the ground. While grabbing at the antlers of the charging animal, the creature was startled by sunlight reflecting off the pious David's crucifix. The image of the cross lit up the stag's antlers. In showing his thanks to the God, who had spared him with such a sign, the king founded Holyrood Abbey on that very spot in 1128.

## Emblems of Trade

Pride in the trade of one's craft was something many of those buried in the seventeenth and eighteenth centuries wanted on their gravestones in Scotland, and indeed across Britain. While Greyfriars is lacking in the great number of these trade emblems, there are still a few that can be seen around the graveyard.

Merchant symbol.

*Merchants*
The most commonly used sign for the merchants is the '4' sign. Although this was the official sign for the arms of the Merchant Guildry of Stirling, it soon spread out across the country in the seventeenth century. The merchant's initials would often be added to the symbol.

*Soldiers*
The weapon carried by the soldier in life is often depicted on the gravestone of the deceased.

*Stonemasons*
As far as remembrance for the deceased through memorials left behind is concerned, these are the men we have to be thankful to. Around the graveyard and on the church building, mason's marks can be found in abundance. The emblems of the mason's trade – the square and compass – can be seen on a number of stones in the grass area to the north of the church.

*Surgeon*
On the east gable of the church is the eye-catching monument to James Borthwick. While the King of Terrors dominates the scene, the surgical implements in the boarders are hard to ignore for the Deacon of Surgeons.

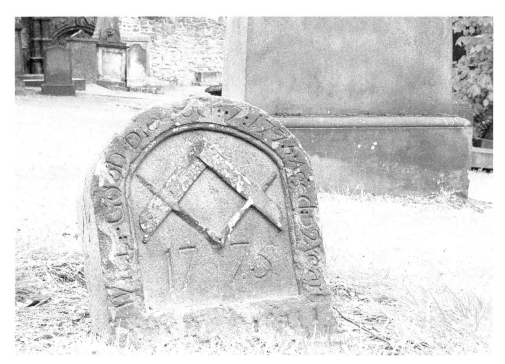

*Above*: Grave of a stonemason.

*Below*: Surgeon's tools.

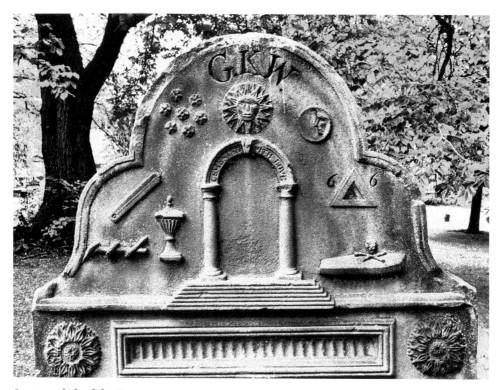

Some symbols of the Freemasons.

## Freemasons

There are a few examples of tombs and stones in the graveyard that bear symbols of the Freemasons – such as the sun, moon and stars. A gravestone in the northern part of the first burial ground belongs to Joseph Knight, who rather than having the occupation of a stonemason is described as a private solider in the Northampton Militia.

## Pilasters

Quite a considerable number of the mural monuments use columns as both support and decorative effect. Below are the type of columns used:

Doric Columns were a popular choice in ancient Greece, often stouter than those of the Ionic or Corinthian orders. Their smooth, round capitals are plain compared to the other two.

Ionic columns are the thinnest of the three. The use of volutes, an unrolled double-scroll shape, often accompanied by the ornamental carving of the egg and dart design, are the most identifiable character of the column.

Corinthian columns are the last developed style of the three principal classical orders. It is by far the most decorative, with capitals adorned with acanthus leaves and scrolls. The columns are slender and fluted.

A barley-sugar column, or a Solomonic column as it is officially known, has a spiral corkscrew-like twisted shaft. It does not have a specific capital, so the defining feature is the column itself.

## Plants and Flowers in Greyfriars Funerary Art

Although the use of flowers and plants in the carvings on tombs are used to give an additional aesthetically pleasing effect, they also serve to embellish the message to be given to those viewing the tombs. They can tell us more about the deceased, adding to the moral and godly devotion they lived by in life in addition to the traditional symbols of mortality and immortality. They can also tell us something more personal: the way others felt about them. Or they can indicate whether they were considered to have lived a long and fruitful life or if theirs was one over far too soon. A single tomb may contain many different types of plants, weaving a tale for us to decipher. In short, the carvings of plants and flowers can give personality to the deceased that we, centuries later, are able to catch a glimpse of.

### Acanthus

The acanthus has been one of the earliest examples of a plant used to adorn memorial architecture to the deceased. It is reputed that the Greek sculptor Callmachus created the Corinthian order in the latter part of the fifth century BC. As legend goes, Callmachus came across the burial site of a young maiden in Corinth. An acanthus had sprouted in the spring through and around the offerings that had been left for the maiden. The sight inspired him to decorate the capital at the top of a column. Although used ornamentally throughout Greyfriars,

Acanthus.

it is also a symbol of immortality. The acanthus leaf is quite thorny and thus symbolises the thorny journey through life with the reward of eternal life in Heaven after an earthly death.

## Cornucopia

Also known as the Horn of Plenty, the cornucopia is a symbol of abundance. In appearance, it is a horn-shaped receptacle overflowing with fruit and vegetables. In some cases, throughout Greyfriars, poppy seed heads are also seen within the fruit and vegetables. The use of the cornucopia symbolises a full and fruitful life has come to an end with the harvest of the soul. There are instances where the fruits are without the horn yet still clumped together. The types of fruit included can also show us the wealth of the person. Those who have exotic fruits would have paid great amounts to have them on their table in life and so in death they continue to show their earthly wealth. However, we must remember that the stonemasons were not wealthy men and probably did not have even more than a passing glance at the fruits in question, if any, which leaves us with some rather weird and wonderful looking fruit (and in some cases vegetables) in the carvings.

## Daisy

The daisy symbolises innocence and purity; it is for this reason they are often used in funerary art on the tombs of children or young unmarried women. Due to this representation, it can seem the saddest flower to see on a grave – symbolising opportunities lost in a life cut short.

## Evening Primrose

The evening primrose's flowers open in the early evening through to midmorning, when it closes. As a symbol of immortality, it represents the blossoming of the soul after

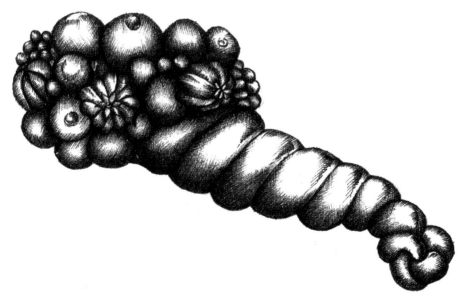

Cornucopia.

death. Life is the closed budded time during the darkness of life. More generally, it also represents eternal love, sadness, hope and memory.

### Fern

The fern is a symbol of sincerity. To give it to someone as a gift signifies that you wish them nothing but the very best. Likewise, when put on a tomb of the deceased it indicates that a wish of the best in the afterlife is bestowed on the departed.

### Forget-Me-Not

Forget-me-nots represent a true and undying love that even death itself cannot end. It is a flower of remembrance, as the name suggests, and reminds us to respect those who have passed and ensure they are never forgotten.

### Grapes

The grape symbolises wine, which in turn symbolises the blood of Christ. The drinking of Christ's blood is carried out during Holy Communion.

### Ivy

The use of ivy or other sorts of vines are a symbolism for both eternal life and the binding of friendship. When three-pointed leaves are used in the decoration it additionally makes it a symbol of the Holy Trinity.

Forget-me-not.

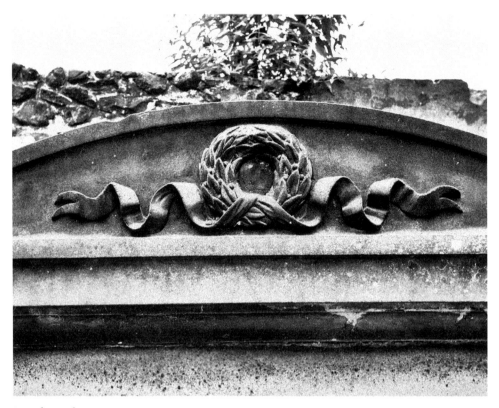

Laurel wreath.

## Laurel Wreath
This represents victory over death and symbolises, due to its evergreen properties, that the memory of the deceased will not wilt. It is also a symbol of authority and respect, showing the position the deceased may have held in the community or how they were respected.

## Lily
The lily is the symbol of purity and innocence. Using one on a grave symbolises the returning of innocence to the soul at the time of death. In Victorian times lilies became a popular funeral flower.

## Lily of the Valley
This flower symbolises the resurrection of the soul, the reason being that it is one of the first flowers of spring – the awakening of the flower after winter is like the soul waking after death.

## Morning Glory
The bloom of the morning glory opens with the morning sun and closes again at dusk. It is due to this that they are a symbol of the resurrection.

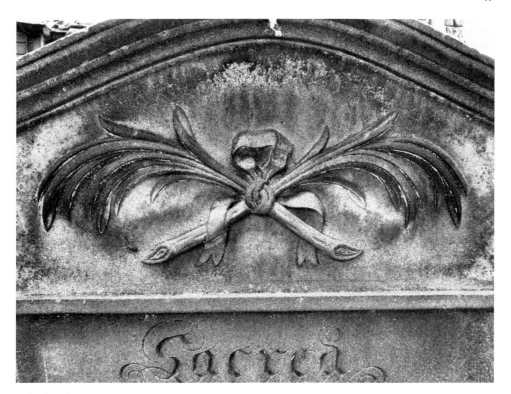

Palm fronds.

### Palm Fronds

Like the laurel, palm fronds symbolise victory over death. First adopted as a symbol of military victory by the Romans, Christian martyrs used the palm to symbolise their triumph over death as they would be granted eternal peace and life once they had passed on from their mortal body.

### Poppy

The commonly associated symbol of the poppy is that of eternal sleep, due to its narcotic properties. The poppy has been associated with Morpheus, the Greek god of dreams. It was his job to shape and create dreams, often making him the messenger of other gods. Morpheus slept in a cave covered in poppy seeds.

### Rose

Roses often have many meanings out with funeral art, depending on their colour: red = love; white = purity; pink = appreciation; yellow = friendship; orange = desire; peach = sincerity.

One common theme through all these descriptions is it symbolises affection for the person who is to receive the rose. The rose bloom is recognisable for its beauty and longevity, but it sits upon a long and thorny stem – just as a Heaven and all its beauty is awaiting the soul after a thorny life.

Sunflower.

### Sunflower

More often than not, the sunflower is found on a tomb of someone who follows the Catholic faith as it signifies devotion to the Catholic Church. There are a couple of examples found in the kirkyard, though they are not in plain sight and may not quite be recognisable to our modern perceptions of a sunflower. Looking up in front of a mural monument such as that of John Byres, under the arch you will see a number of flowers, the sunflower included.

### Wheat

The use of wheat on a tombstone (when not being used to denote an occupation) will indicate that the person lived a long life and has passed the age of seventy. Wheat is one of the earliest grains to be described in the Bible and is considered to be a gift from God, due to it being used in so many foods. It is a symbol of immortality and resurrection. Often it will be used as background to some other symbolism, such as a death head.

### Closed Bud

The closed bud represents the short life or passing of a baby or a young child.

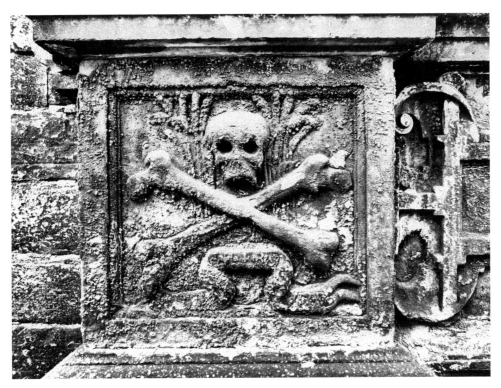

Wheat and death head.

## Broken or Clipped Stem

This denotes life that was unexpectedly cut short. The same can apply to tree branches, but there doesn't seem to be an example of this in Greyfriars. (Though, that said, during the on-site research for this book, even after working in the kirkyard for over thirteen years I still find something new each time!)

# 4. Bodysnatching

During the eighteenth and nineteenth centuries Edinburgh was experiencing great advances in the medical world. A leader in the field of surgery and head of a great family of surgeons was Alexander Monroe I. After studying anatomy in Edinburgh, London, Paris and Leyden he returned to Edinburgh to become professor of anatomy and surgery at the Surgeon's College, opening dissecting rooms in Surgeons' Square in 1719. In 1720 he was to become the University of Edinburgh's first professor of anatomy, a post he held until his son, Alexander Monroe II, took up the position in 1764. Upon his retirement in 1808 it was the turn for the grandson, Alexander Monroe III, to become professor of anatomy and surgery. All three men are buried in Greyfriars.

With such success came the need for bodies to dissect. Religious and moral guidelines along with the beliefs of the era meant most people were opposed to the notion of human dissection; nevertheless, Edinburgh Town Council were in agreement with the surgeons that the need for human anatomical dissection was essential for the training of would-be surgeons. The bodies of prisoners who had been executed or died in custody were turned over to the medical school. However, with the increasing interest in human anatomy and a growing desire for better medical treatment, the allocated supply of bodies was nowhere near enough to meet the demand. This led to a black market being opened whereby anatomists would offer money for bodies to sell on to their students. The bodysnatchers, or resurrectionists, as they were known, would disinter the bodies of the recently buried deceased to sell to the surgeons.

Being one of the closest burial grounds to the medical school, Greyfriars was regularly raided, especially in the first thirty years of the nineteenth century when bodysnatching reached its peak. The number of medical students had increased across Scotland, especially in Edinburgh. During the early nineteenth century each student, studying over a sixteen-month period, required three bodies. The first two were to learn about the anatomy of the human body, with the third used for practicing surgical procedures on.

As public awareness of the resurrectionist activities increased, so did the risks involved in bodysnatching; however, the monetary benefits were soon apparent to anyone wishing to profit from such a socially unacceptable job. In the early nineteenth century, the wage of the working classes was as low as 9s a week in rural areas; even skilled workers in urbanised areas seldom earned more than 30s a week. In comparison to these low wages, by 1810 the average well-preserved adult body could bring a resurrectionist an income of £4, rising to between £7 and £9 by 1820.

There was a genuine fear from the people of Edinburgh that their remains and their departed loved ones would end up on the medical school's anatomy table. In a letter addressed to Gilbert Innes of Stow on 30 May 1793, the writer, a Mr William McLaurin,

assures Mr Innes that the body of his late wife, Effie Burnet, is being guarded as he has employed watchmen to stay by her grave since her burial seven days prior: 'We suspect the surgeons have a desire to open her, which must not be allowed.' From this correspondence it is clear that the practice of the resurrectionists was common knowledge among the citizens of Edinburgh, and why they were doing it. In the *Caledonian Mercury* dated 3 October 1807 an article was published identifying that the public mind has been considerably agitated concerning the infamous and inhuman act of stealing the dead. The increase of general knowledge and public outcry towards resurrectionists led the citizens of Edinburgh looking towards means of protecting the dead.

While the selection of bodies was classless, all being equal in value to the surgeons, the poor were certainly more susceptible to their loved ones being stolen. This was not only due to the fact they could only afford cheap coffins (if indeed one was used at all), but also that a poor person's grave was shallow and could contain multiple bodies in a single burial. Therefore, those who could not afford paid watchmen would guard their own family plots from sunset to sunrise for around a month to six weeks. The bothy situated next to the main gate was built in the 1830s, intended to be used as a watch house. It is semi-octagonal with windows on each wall, except for the door. However, after the 1832 Anatomy Act and the end of bodysnatching its original purpose was made redundant and its use changed to that of a funeral bothy.

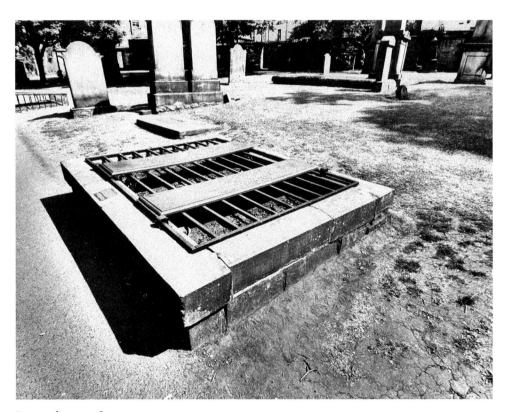

Restored mort safe.

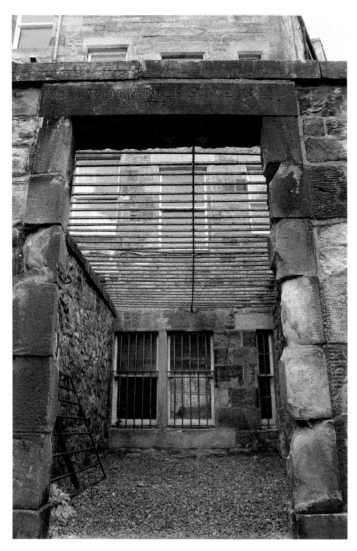

William Ingles.

The mort safe is a lasting reminder of the resurrectionists. In the southern area of the churchyard, behind the south wall of the church, are two fine examples. The first is still in its original state. The metal cage would be fitted over the recently buried, meaning the body could not be reached without a key. The second was repaired by Edinburgh World Heritage. It is the burial plot of Major M. E. Lindesay for his two daughters. Although buried in 1837 and 1838 – after the 1832 Anatomy Act was passed – he obviously did not believe the Act had succeeded in stopping all bodysnatching.

Some of the burial enclosures are also fitted with iron gates and bars over the top of the burial grounds to stop the illegal entry. The tomb of surgeon William Ingles, buried in 1792, is perhaps one of the biggest indicators that this surgeon knew exactly what was happening in Greyfriars and did not want to end up on the anatomists table or, worse yet, as a learning tool for a student.

# 5. Monuments of Note

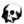

The number of wonderful monuments dedicated to the much-loved deceased members of some of Scotland's most notable families captivates visitors throughout the graveyard. While many of these people may not be famous in their own right, their monuments leave a lasting impression, making Greyfriars one of the most famous graveyards on the British Isles. In this chapter a (very small) selection of notable burial markers and their occupants will be looked at in more detail. All spelling used on monuments and in documents have been reproduced here as they are seen on the original source.

Many of the inscriptions are in Latin, Old Scots or even other languages. The known translations from Latin to English were done by Revd Robert Monteith, who took great pains to translate all the monuments in Greyfriars. Throughout this book all Latin translations are taken from Monteith's work entitled *An Theater of Mortality; or, the Illustrations Inscriptions exant upon the several Monuments, erected over the dead Bodies*

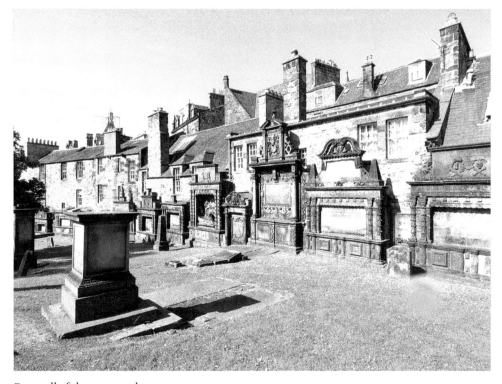

East wall of the graveyard.

*(of the sometime Honourable Persons) buried within the Gray-friars Church-yard; and other Churches and Burial-Places within the City of Edinburgh and Suburbs: Collected and Englished by R.Monteith M.A.* He wrote this in 1704 and thanks to his recording and later the kirkyards' sexton James Brown's book *The Epitaphs and Monumental Inscriptions in Greyfriars Churchyard, Edinburgh,* written in 1867, we are able to read a number of epitaphs that have since weathered and disappeared with the passage of time.

Monteith was himself interned in Greyfriars after his death. However, it is with deep regret to note that no monument was ever erected to the man who spent years preserving the memory of others after their passing. Monteith, almost predicting such an outcome, wrote in 1713: 'Of many men, I sing the mournful fate; Yet I perhaps may fall, without regret, Thou likewise.'

## Dennistoun of Dennistoun (East Wall)

The noble Dennistouns are one of the oldest families in Scotland, going back to the reign of David I. Sir Hugh de Danzielstoun was one of the Scottish barons who had been forced to swear allegiance to Edward I of England. His great-granddaughter Elizabeth Muir went on to marry Robert II in 1347, and was mother to Robert III of Scotland. It is perhaps with such a lineage that this family would have such a magnificent tomb on the east wall of Greyfriars. Of all the large mural monuments in Greyfriars it is one of the best-preserved tombs and it is covered in carvings, most of which we would expect to see on a tomb of its time. At the top is the family's coat of arms.

The freshness of the carvings gives the impression the tomb is much newer than its 1626 erection for Sir Robert Denystoun of Mountjoy. The Latin inscription translates as:

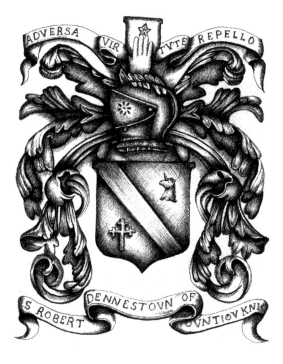

Dennistoun family crest.

Behold, the world possesseth nothing permanent Sir Robert Denystoun lies under this tomb. He was formerly the Kings ambassador and for thirty years conservator of the Scottish Priviledges in Holland. He was also sent to and behaved with glory among the English and the Spanish. True to his country, counsellor to his prince and being full of days, having lived 78 years, he now liveth in the heavens.

## John Nasmyth of Posso (East Wall)

On the east wall there is one tomb that instantly grabs the attention of the viewer due to its unusual display of a bodyless person rising from their deathbed. The recess is taller than those nearby to represent the space for John Nasmyth's soul sitting up, which is flanked at either side by trumpeting angels of the resurrection and accompanied by the words from 1 Corinthians 15: 55: 'O death where is thy sting? O grave, where is thy victory?'

John Nasmyth was the second son of Sir Michael Nasmyth of Posso, an ancient Scottish family who have held lands in the Tweeddale since the thirteenth century and were loyal royalists. The tradition of the surname comes from an ancestor who had been part of Alexander III's army. The evening before the battle, seeing the poor state of the man's armour, the king commanded he should fix it for the following day. Though a fine warrior of strength and heart, he was not so skilled at repairing armour, but he did not let this hinder him. After the battle the king knighted the man for his valour, remarking that although he was nae smith, he was a brave soldier. It is from this story that the crest contains a drawn sword and two broken hammer shafts with the words '*nom arte sed marte*', which translates as 'Not by art but by war'.

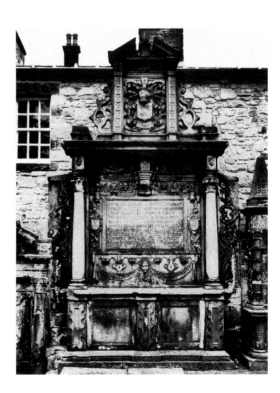

Dennistoun mural monument.

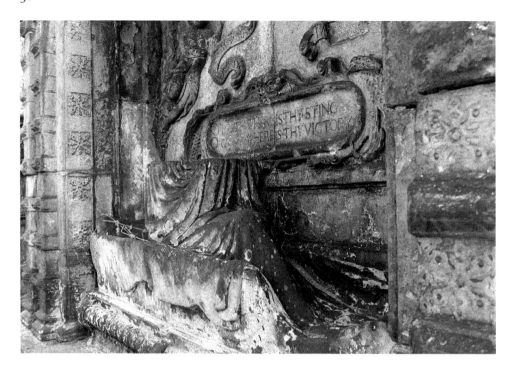

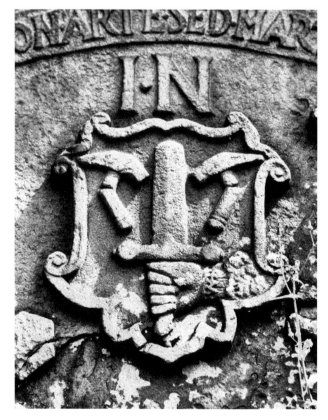

*Above:* Resurrection scene on the Nasmyth monument.

*Left:* Nasmyth coat of arms.

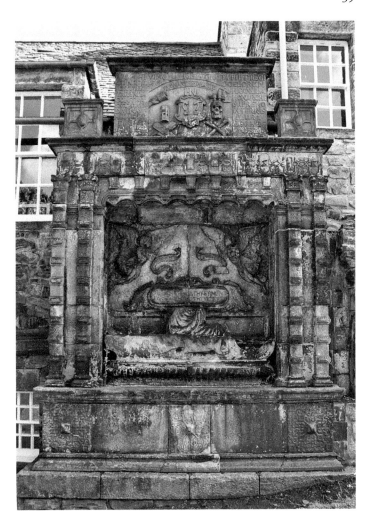

Nasmyth.

Michael Nasmyth had been a staunch supporter of Mary, Queen of Scots and likewise his son John was loyal to his monarch, James VI, becoming chief 'churgeon' (surgeon) to the king. Not only did he serve James VI but also the king of France, and it was said that when John died in London on 16 September 1613 both the countries of Scotland and France grieved his passing. The translation reads:

> Here lies john Nasmyth, of the family of Posso, an honourable family in Tweeddale, a citizen of Edinburgh, chief churgeon to his most serene Majesty, and to the King of France's troop of guards from Scotland, having notably performing all of the duties of a godly life; who dying at London, to the grief of both nations, in the exercise of his office with his Majesty, ordered his body to be transported hither, such was his love to his country, to be buried in this dormitory acquitting himself to the King, his country, and to his friends to the utmost of his power and duty. He died in his 57th year of his age, 16th September 1613. Why is it grievous to return where you came?

## George Buchanan (Near the East Wall and North of the Kirk)

George Buchanan is one of the select few who has more than one grave marker in the graveyard. Buchanan has two markers that are not only in different areas but also in very different styles. In addition to these markers there is also a window in Greyfriars Kirk dedicated to him.

Although the exact location of the burial spot of Buchanan has long since been forgotten with the removal of a possible early marker in 1603, the site of the first marker dedicated to him is thought to be in the most likely position near to the east wall. This metal marker stands around 2 feet tall and is now a blue colour due to age, but is still in a good condition and easy to read:

> In this cemetery are deposited the remains of George Buchanan, Scottish Historian, one of the most distinguished Reformers of the sixteenth century and the best Latin poet which modern Europe has produced. He was born in the Parish of Killearn, Stirlingshire, in February 1506, and died in Edinburgh on the 28th September 1582.

This marker is said to have been placed over the grave by a local blacksmith who erected it at his own cost in around 1870. In 1878 a second monument was erected by Dr David Laing, a man of great learning and an admirer of George Buchanan. The 6-foot-tall square sandstone pillar contains a remarkable bust of Buchanan in an oval alcove. It can be seen north-west of the church, the reason for this choice of location has not been established.

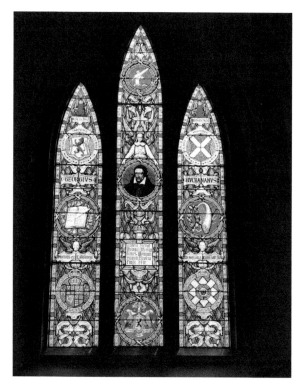

George Buchanan's window in Greyfriars Kirk.

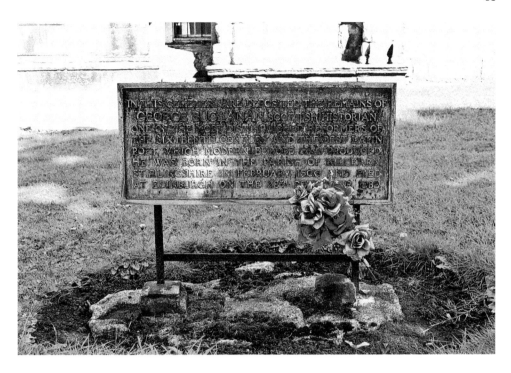

*Above*: George Buchanan's metal monument.

*Right*: George Buchanan's monument.

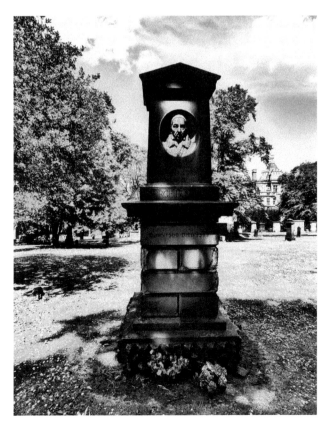

George Buchanan was a famous scholar, historian, poet, councillor and tutor to royalty. He was born in February 1506 to Thomas Buchanan and Agnes Heriot. His father died when he was quite young, so his uncle James Heriot paid for his education. The young Buchanan studied at the universities of Paris and St Andrews.

With the Reformation, Buchanan embraced the Reformed Church. Unlike the fanatical John Knox, however, he practiced the new religion as a humanist and a scholar, which enabled him to advise Mary, Queen of Scots on the ways of the country on her return to from France – a country now completely alien to her. Despite their religious differences with Mary, who was a devout Catholic, they got on well. It is said that he did not disguise where his religious sympathies lay, yet he was on good terms with the queen up until the murder of her husband, Lord Darnley. With her marriage to the Earl of Bothwell, Buchanan turned with complete revulsion on the queen and he did all that he could to both remove her from the throne and ensure she would never regain power again.

It is perhaps due to this attitude and his scholarly attributes that led the Privy Council to appoint Buchanan in March 1570 as tutor to the four-year-old James VI. It was in a schoolroom in Stirling Castle that Buchanan taught the young king along with his childhood companions – the Earl of Mar, Sir William Murray of Abercairney and Walter Stewart, the later Lord Balantyre and Lord Invertyle.

James was a keen pupil, but the one point they clashed on was the divine right of kings. Regardless of his royal status, Buchanan was known to strike his charge when he believed the occasion arose. When James VI became king of England, becoming James I, he was quick to adopt the divine right of kings.

## John Bayne of Pitcarley (North Wall)

One tomb that invites speculation and wonderment can be found against the north wall of the graveyard. It is the mausoleum built in the memory of John Bayne of Pitcarley. Looking through the metal gate of the high-walled enclosure, the rather commanding statue of John Bayne stares back from underneath his shallow domed canopy. Dressed in period clothing and with a sumptuous cloak, his hair hangs loose and slightly curled to his shoulders. In his hand he appears to hold a money bag or a stack of papers. There are carvings of mortality and immortality that add to the overall appearance of this remarkable mausoleum. Sadly, the monument has not weathered the years so well: John Bayne has lost his nose and the front of his shoes to vandalism and the roof has buddleia growing from numerous cracks. Unfortunately, there is no plaque for John Bayne; the only name is that of James Cathcart, who was buried there 100 years later. Along with Bayne, his wife and Cathcart the interment records between 1688 and 1700 identifies a further thirty-nine people within the Bayne tomb, so it is surprising there was even room for Cathcart to be buried there!

John Bayne was born in Edinburgh in 1620. In adulthood he was a writer to the signet, qualifying in 1655. Along with his regular legal work he also supervised the preparation of the building contracts for the renovations at Holyrood Palace in 1672. A man of learning, he endowed student bursaries at the universities of Edinburgh and St Andrews that were being granted up until 1901, ensuring the education of many within those years.

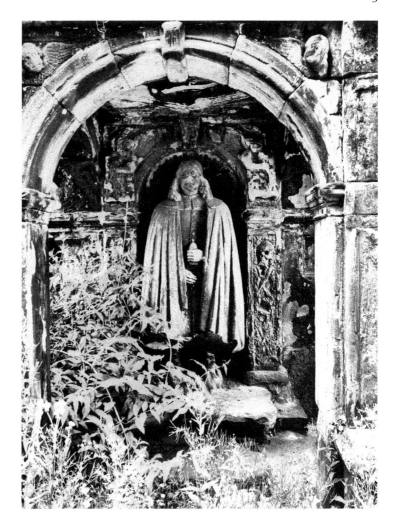

*Right*: John Bayne's statue.

*Below*: John Bayne's enclosure.

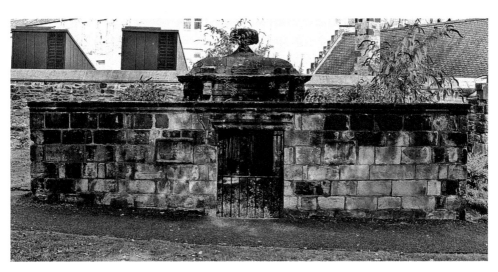

## James Douglas, 4th Earl of Morton (Near North Wall)

The rather unusual marker for James Douglas, 4th Earl of Morton, can be seen in the area once known as the Criminals Ground. It is a short, stubby, cylinder marker simply inscribed with 'J.E.M.' – for James, Earl of Morton. There was no original marker for the earl and the current marker was added in the Victorian era.

During his life the earl was a man of high ambition, staying close to the Crown and becoming the fourth and final regent to James VI of Scotland while he was in his minority. During his time as regent he was able to bring the civil war in Scotland to its conclusion, ending the hopes of any restoration of Mary, Queen of Scots to the throne.

While civil unrest may have been settled, his actions amassed him great unpopularity with many, leading James VI to take up his mantle as ruler of his kingdom at the age of eleven without a regent to rule in his place. Morton was to briefly gain power once more before he was implemented as a leading member of the nobles who murdered Lord Darnley, the king's father, who died at Kirk o' Field on 10 February 1567. His chief accuser was James Stuart, Earl of Arran, who on 31 December 1580 used a meeting of the council at Holyrood to publicly declare Morton an accomplice to murder. Though it could not be proven that Morton had been part of the actual act, his admission that he knew of the plot through the confession of the Lord of Bothwell sealed his fate.

The Earl of Morton was beheaded on 2 June 1581 by the use of the Maiden, a predecessor of the guillotine. His head was set upon the tollbooth, while his body was hastily buried in Greyfriars. His head remained in place until 9 December when the king ordered it be removed and buried with his body.

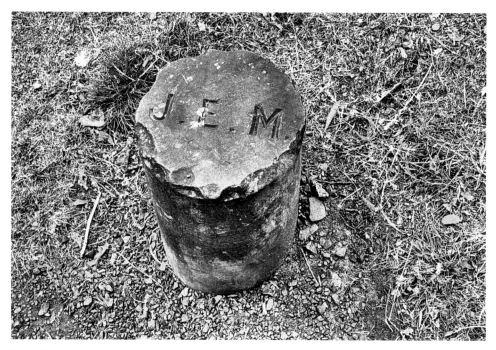

James Douglas.

## Alexander Douglas (North Wall)

On the north wall is the 'Hatter's Tomb', now sadly all but covered by shrubbery planted by well-meaning garden enthusiasts. While images of Alice's eccentric friend may spring to mind when speaking of the Hatter's Tomb, this is actually not far from the truth as Alexander Douglas was indeed an eminent hatmaker in Edinburgh. The stone itself has been in a considerable state of disrepair for well over a hundred years. Part of Douglas' crest can still be seen with a clear heart at the top of the stone. The inscription is long gone, but thankfully Robert Monteith recorded it in his book: '*Hodie mihi, cras tibi* [Today is mine, tomorrow may be yours]. Monumentum Alexandri Douglas. Here lyeth Jean Douglas who deceased the 2d August 1667, her age 39. Alexander Douglas, himself deceased 14th October 1669, his age 55. Walter Douglas, his son deceased 24th May 1670 his age 25.'

The Hatters of Edinburgh had been a recognised body since a charter had been passed on them by the Common Council of Edinburgh on 18 February 1473. No one could work as a hatter or bonnet maker without the say so of this important body of people. To be known as a hatter was a status symbol. This is currently the only known hatter's monument in Edinburgh.

The Hatter's Tomb.

## Thomas Bannatyne (West Wall)

The monument dedicated to Thomas Bannatyne on the west wall is a rather magnificent example of craftmanship to be found in the graveyard, withstanding the passing years better than many of the monuments of a similar era. The uppermost portion was taken down in the 1920s for safety reasons and spent over sixty years on the ground before being restored to its rightful position. It is perhaps due to this that it is much fresher-looking than the rest of the monument.

With its barley-twist columns and rich imagery, it quickly catches the eye of the beholder and keeps it there for some time. One of the most notable additions to the monument is the fact that the main inscription is in English rather than the commonly used Latin on seventeenth-century tombs:

If thou list, that passest by,
Know who is this tomb doth ly, Thomas Bannatyn, abroad,
And at the home who served God
Though no child he posset
Yet the Lord with means him blest
He of them did well dispose
Long ere death his eyes did close,
For the poor his helping hand,
And his friends his kindness fand,
And on his dear bed fellow,
Jennet McMath, he did bestow,
Out of his lovlie affection,
A fit and goodlie portion
Thankful she herself to prove
For a sign of mutuall love,
Did not paines nor changes spair
To set up the fabric fair
As Artenise, that nobel frame
To her dear Mausolus name
He died 16th July 1635, of his age 65.

The monument was erected by Thomas' wife Janet McMath, a most estimable woman whose kind and charitable nature was well known. Thomas was Janet's first husband and his death left her a wealthy woman. He left his entire estate to her. He was a successful merchant and burgess of Edinburgh by the time of his death in 1635. Janet, who was younger than her first husband, was remarried two years after his death to William Dick of Grange. It was her wealth and generous nature that enabled her to save the Grange estate when her father-in-law, Sir William Dick of Braid, got heavily into debt. When he died in a state of poverty in London it was Janet herself who travelled to the English capital to bring his body back and had him laid to rest in his own grave in Greyfriars (now gone).

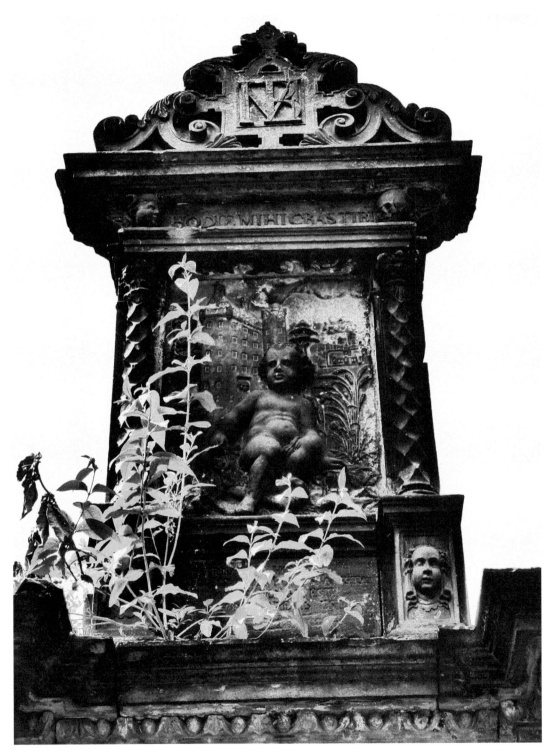

Top of Bannatyne monument.

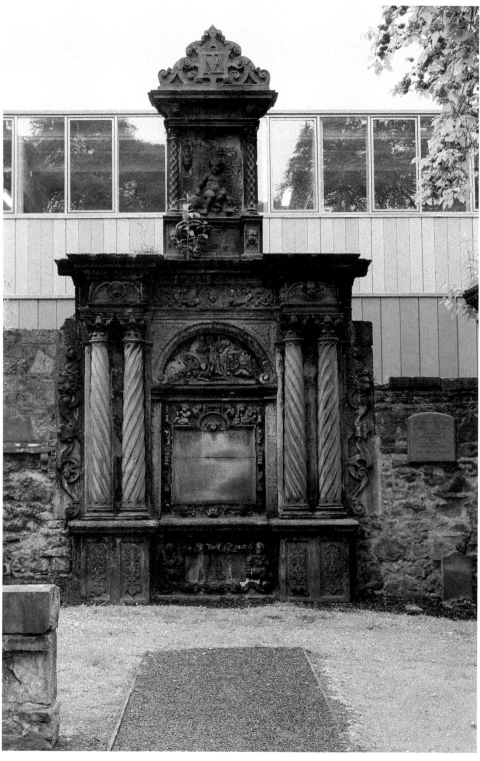

Bannatyne monument.

## George Foulis, Laird of Ravelston (West Wall)

This monument by William Ayton is perhaps the most spectacular and finest in the graveyard – it certainly would have been when first erected. A wealth of figures and symbols fill every surface. Even after many years of studying this tomb and taking countless photos, something new catches the eye. It is unfortunate that some of the figures have not withstood the passage of time. It is evident that great care, love and expense was lavished on this memorial, which was erected by their son George. The Latin translation on the monument reads:

> George Foulis of Ravilston, son of George erected this to the pious memory of his parents. A firm bond unites the blessed in Christ, whom gloomy death hath torn asunder. Consecrate to the memory of that excellent man, George Foulis of Ravilston, of the noble family of Colintoun, master of the kings mint, baillie of the city of Edinburgh and sixteen years a counsellor, who in every charge private and public, was of eminent faithfulness and integrity; and amidst the spendour of his flourishing family with the greatness of his fortune, of so great modesty and moderation of mind, that he was dear to all good men, hateful to none, no, not to the wicked. Having arrived at a good old age, he happily closed his honest life with a godly end, 28th May 1633, of his age the 64th year. Here he laid down the spoils of his morality, in hope of a new life, together with his dearest

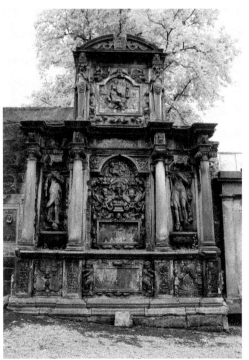

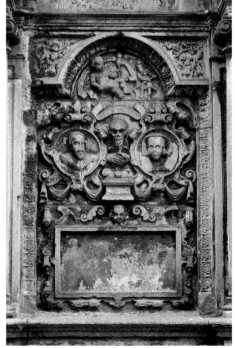

*Above left*: Foulis tomb.

*Above right*: Detail on Foulis monument.

spouse, Janet Bannatyne, with whom he had lived 29 years in the greatest concord. He left six sons surviving; and as many daughters. He had five sons dead before him and one daughter, who ushered him the way to the heavenly kingdom.

From the inscription above we can get a glimpse into the seventeenth century. Life expectancy was much younger than today, as he is described as being a fair old age at sixty-four when he died; had he lived in the present day he would not yet be eligible for a state pension! The number of children they had together may seem startling, yet having twelve children survive infancy shows they were brought up in a wealthy household, as in a poorer home they may have lost more. The fashion of the day has also been immortalised on the medallion portraits of George and his wife. These portraits seem to have included to honour the dead and also represents the love between husband and wife. There is also the addition of the clasping hands, as if in a handshake, which although is often considered a symbol of farewell, in this case it is more likely to be a sign of reunion between the spouses. This theory is further supported by the use of the heart, with the figure of Death showing they were reunited by his hand. At their old house of Ravelston a lintel is visible with the initials of George Foulis and his wife Janet: 'GF. *Ne quid Nimis*, 1622 JB.'

## John Byres of Coittes (West Wall)

The mural monument for John Byres of Coittes may not be the most magnificent tomb on the west wall but, due to its symbolism, it is certainly one of the most interesting. While it contains a lot of the usual symbols of both mortality and immortality that we would expect to see, it also contains the rather rare symbol of the fallen tower – the only example to be found in the graveyard. While the tombs of the seventeenth century usually have the message of mortality as its primary theme, this tomb's central theme is about resurrection and immortality. It clearly indicates the wish for the departed's swift ascension to Heaven as in life he was considered a good man. The translation reads as, 'To a man truly good, and excellent citizen, John Byres of Coittes six years together treasurer of this city, two years city baillie and suburban baillie, six years Dean of Guild and two years Old Provest; his wife A.S. and his children have erected this homely monument. He died, much lamented, 24th November, the year of Christ 1629 and of his age 60 years.'

John Byres has been described as a prominent citizen in Edinburgh during the reign of James VI as well as a much-respected merchant. A close across from St Giles' on the High Street still bears his name where his townhouse once stood. On a lintel that was once over the entrance were the words 'Blissit be God in al his Giftis', along with the initials of John Byres and his second wife Agnes Smyth, daughter of Robert Smyth, burgess of Edinburgh. When the building was reconstructed in 1811, Sir Patrick Walker had the lintel removed and installed at Coats House, the one-time country house of John Byres. Fortunately, the ancient Coats mansion still stands. The estate of Coates was bequeathed to the Scottish Episcopal Church for the erection and maintenance of a cathedral. St Mary's Cathedral is situated at Palmeston Place, with the Coates mansion in the grounds still being used by the church.

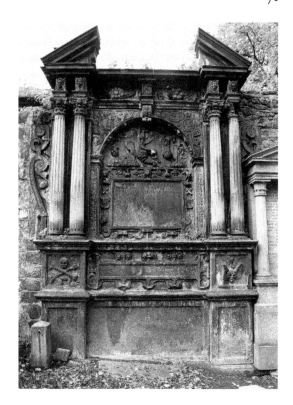

*Right*: John Byres of Coittes.

*Below*: Detail on Byre's monument.

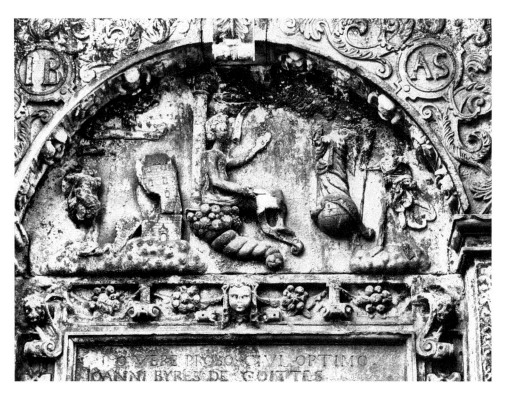

## William Adam (Upper West Wall)

The Adam mausoleum is the largest mausoleum in Greyfriars Graveyard, measuring 15 square feet and a height of 30 feet. It is striking with its high round-arched entrance and its entablature decorated with ram skulls and rosettes. It has an iron gated entrance that enables visitors to look in and read the inscription panels. The principal panel is dedicated to the Scottish architect William Adam, who died in 1748. The building of the mausoleum was completed in 1753 by his son John Adam. A bust of William Adam is seen on the rear wall above a tomb chest with Hopetoun House carved in its front.

William Adam's connection to Hopetoun House came in 1721 when he was commissioned to undertake an extensive project of improvements and alterations to the grand house. This included the addition of the magnificent east façade with its colonnades, pavilions to the north and south, as well as the creation of state apartments for the use of entertaining guests and family alike. When he died in 1748, his sons – John, Robert and James – carried on his work, completing the interior decoration in 1767. It is clear that Adam was influenced by grand European palaces such as Versaille, giving Hopetoun a sophisticated appearance that has withstood the passage of time and still looks as splendid 270 years later as it did then. Other buildings accredited to Adam include Floors Castle, Hamilton Old Parish Church, Craigdarroc, Drum House, Mavisbank House, Duff House, House of Dun, Haddo House, Chatelherault, Taymouth Castle, Cumbernauld House, Robert Gordon's Hospital and the original Royal Infirmary of Edinburgh on Infirmary Street. He also acted as 'intendent general', overseeing the building of Inverary Castle.

William Adam bust.

Houptoun House.

With his wife, Mary Robertson, they had ten children, three of whom became architects as mentioned before. He died 24 June 1748 at the age of fifty-eight. His architect son John is also buried in the great mausoleum that he built for his father. There is a memorial within the church building to Robert Adam.

## Sir James McLurg of Vogrie (Covenanters' Prison)

The monument for Sir James McLurg of Vogrie is rather unusual for its time, and indeed the only one of its kind in the graveyard due to what is written on it. It dates from 1717 and lists the details of all who benefited from his death. His monuments reads:

> *Here lyes Sir James McLurg of Vogrie, late Dean of Guild of Edinburgh, who died the 6th of Oct. 1717, in the 88th of his age. He left large legacies to his friends, and 22,000 merks to pious uses, viz.-*
> *To the common poor of Edinburgh 4000*
> *To the trinity Hospitall 2000*
> *To the Merchants Maiden Hospitall 5000*
> *To the Trades Hospitall 1000*
> *To the College od Edn., for a bursary of Divinity 3000*
> *To erection of a free school in Edinburgh 3000*
> *To the Tolbooth Kirke for silver plates 1000*

*To a free school in Camonell 1000*
*To a free school in Vogrie 0500*
*To poor hous-keepers in Edr., 0500*
*James Adam, now of Vogrie, caused erect this tomb to the memory of the deceast Sir James*
*MacLurg of Vogrie, and in obedience to his will*
*Job chap. Xix the 25, 26 and 27 verses, 'For I know thatmy Redeemer liveth,' & c,*
*Prover. Chap xix and verse 'He that hath pity upon the poor lendeth unto the Lord,' & c.*

William Adam mausoleum.

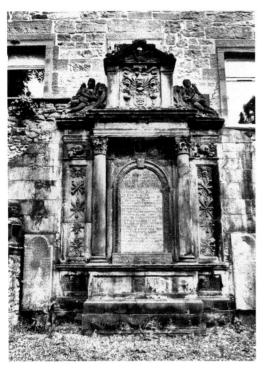 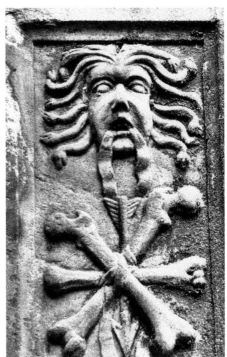

*Above left*: McLurg monument.

*Above right*: Medusa.

Sir James McLurg was an obviously charitable man in life who cared for the welfare of the poor and needy, therefore it is only fitting that his good deeds be remembered after his death and just who should benefit.

His tomb also contains a rather interesting addition to the usual symbols expected on an early eighteenth-century tomb: at either side, above triple crossed bones, are Medusa heads. Medusa was a gorgon from Greek mythology, described as a winged woman with snakes for hair. She had the ability to petrify anyone who gazed at her eyes; even after she was beheaded by Perseus her head continued to retain its powers. Perseus eventually gave the head to Athena, the goddess of war, to put on her shield. When Medusa was beheaded the winged horse Pegasus emerged from the severed head. The use of Pegasus on grave markers, especially in Italy, symbolises resurrection and renewal. It is interesting that Medusa was used and leaves an open question as to why. Was it a symbol of resurrection? A warning to his fellow man? Or simply personal taste and decorative adornment?

## Sir George MacKenzie of Rosehaugh (South Wall)

The stunning mausoleum of Sir George MacKenzie was considered to be architecturally advanced for its time. The designer and mason who worked on its construction was James Smith and it was modelled on the Tempietto di San Pietro. Commissioned by MacKenzie himself, it was completed in time for his funeral. The octagon shape is topped with a

round dome, giving the impression it is circular in shape. The large scallop shells at the top of each of the niches (bar the entrance) is an interesting addition giving the design and elegance. The mausoleum consists of an upper room, then there is a staircase through a grate in the floor that leads down into the burial vault, where lead-lined coffins would sit on stone plinths. In this respect it is unique in its construction compared to other mausoleums, which do not have obvious entrances to a burial chamber. There is no other tomb like it in the graveyard and as such demands the attention it deserves. In 1892, descendants of MacKenzie – the Marquis of Bute and the Earl of Wharncliffe – had the mausoleum repaired.

Sir George MacKenzie was known as Bluidy MacKenzie due to his harsh dealings with the Covenanters and his reputation as a cruel man, devoid of empathy towards his foes. Torture was often used when he sought to extract the truth from one of his victims, taking pleasure in their suffering. He was appointed king's advocate in 1677 and held his position in authority through the Killing Time, until his fall from power in 1688. It is surprising

Sir George MacKenzie.

to note that he died from natural causes – on 8 May 1691. It is said that due to his crimes against humanity, his soul would never be able to rest. Legend has it that his coffin is said to move around in the chamber under his magnificent mausoleum.

While there is no denying that MacKenzie was a tyrant, he did gift one very important institution to the city. He was a lover of literature and wrote many works himself. He founded the Advocates Library in 1682, which later became the National Library of Scotland.

## Forrester Enclosure (South)

Situated on the south wall is the rather plain burial enclosure for Alexander Forrester and his family. Born in St Andrews in 1631, he was a minister who refused to conform to episcopacy in 1662 and was confined to his parish of Livingston at St Mungo's Kirk. He died on 24 May 1686. His son, William Forrester, writer to the signet, had the enclosure built in 1701, perhaps just in time for his own death on 1 October 1701.

What makes this tomb interesting is not so much its style or who it was built for, but for the collection of graffiti marks that can be found on its internal walls, dating from the early eighteenth century. These range from initials and names (some in quite elegant script) to a house- or tent-like shapes topped with flags. Regarding who put these marks here, the only knowledge we have is their name. The most likely explanation is that they were children from Heriots Hospital, who would spend time in the forbidden graveyard grounds, often trying to provoke the spirit of Sir George MacKenzie in his nearby mausoleum by shouting through the keyhole, 'Bluidy MacKenzie, come oot if ye daur, Lift the sneck and draw the bar.' They would then race from the grounds as if MacKenzie was indeed close on their tail.

To the rear of MacKenzie's mausoleum, the external wall houses more graffiti, hidden from view of any passers-by. Closer examination of the enclosures of the south wall also reveals more examples.

Forrester enclosure.

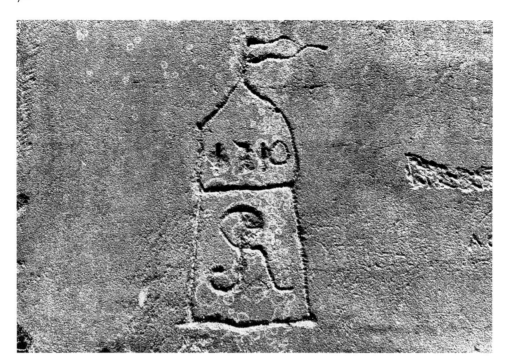

*Above and left*: Graffiti.

## Little or Litill Tomb (South)

Not only one of the earliest burials in the graveyard, this was certainly the first burial plot of the southern part of the graveyard. Clement Little died in 1580 and was later followed by his brother Lord Provost William Little in 1601. Burial in this part of the graveyard was rare, with most burials taking place in the northern burial yard. There is no surviving documentation to explain why the Littles were granted this previously unused section.

Clement Little, son of an Edinburgh merchant and burgess, was educated at St Andrews and Louvain before returning to Edinburgh as a lawyer in 1550. He was admitted to the Faculty of Advocates in 1553. By the Reformation in 1560 he was established as a

converted Protestant. He amassed a great location of reformist theological works, leading the way a year later to serve as an elder on Edinburgh's Kirk Session. He had a notable presence within the Church both as a kirk advocate and as one of the four members of Edinburgh's commissary court. Education was important to Clement, along with his brother William and the Revd James Lawson; they are considered to be the true founders of the University of Edinburgh.

Between 1680 and 1683 a descendant of the Little brothers erected the monument to their memory, which can be seen in Greyfriars today. Although badly eroded, first through damage when the tenements at the rear were built, then the passage of time, it is still a unique and striking monument. Behind a gated entrance and flanked by stone lamps is the body of the monument, consisting of a marvellous canopy with frieze and cornice being held up by ten Corinthian pillars. Underneath the canopy is a deathbed scene, on which there is an alter tomb; resting on this a figure is seen, propped up by a pillow. At each corner of the roof are female figures representing embodied morals. They have been documented as Justice, Mercy, Faith and Love. However, the two figures said to be Mercy and Faith actually appear to be Constancy and Democracy, identified by how they have been depicted. The translation from Latin follows:

The Little tomb.

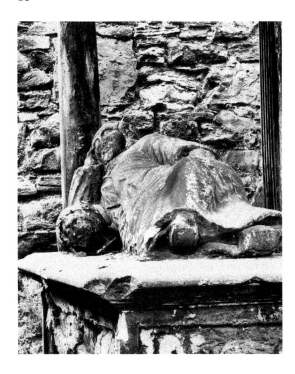

Deathbed in the Little tomb, accompanied by the head of one of the virtues.

To the memory of his great grandfather, on the fathers side, William Little of Over-Libertoun, sometime provost of Edinburgh, his great grandchild erected this monument 1683, Here also beside his brother, Mr Clement, elder than the Provost Commissaries in the Metropolis, waits the Resurrection.

What Clement was, how great the Little were
This citizens that Biblioteck declare.
This Nobel pair of brethren did contend
In merits great each other to transcend,
For both did good; this to the Mother-Town,
Thay to the Muses, whence came their renown.

## Borthwick Monument (East Wall of the Kirk)

The very first monument that grabs the attention of visitors entering the graveyard by the main gate is on the east wall of the church. An almost life-sized skeleton – the King of Terrors – draws the eye and sets the imagination running, inviting onlookers to get a closer look at its grizzly beauty. In one hand he holds the book of Destiny and in the other hand is the eroded outline of a scythe. The positioning of the bones has been likened to the St Andrew's Cross. It is quite unique in the sense that there are no other tombs in Greyfriars that replicate the style, though the King of Terrors has been used on a much smaller scale as part of a scene on several tombs across the graveyard, especially on the west wall. In the panels at either side, along with emblems of mortality, are the carvings of surgical implements, revealing the occupation of the deceased. Again, this is something unique to this monument.

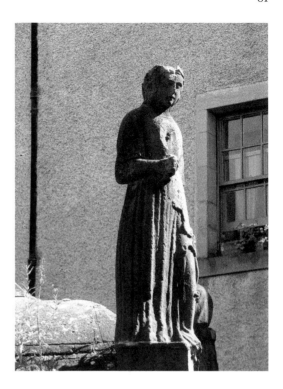

Personified virtue.

The monument belongs to James Borthwick, a renowned 'chirurgeon' (surgeon) of his time and deacon of chirurgeon in Edinburgh. He bought the plot in 1670 and was laid to rest there seven years later. The inscription below the monument is now gone, leading many visitors to the graveyard to wonder who it was dedicated to. Luckily Monteith recorded the inscription: 'To the memory of his father, James Borthwick of Stow, lawful son of the Cruixtoun family, most famous Chirurgeon Apothecary, Mr James Borthwick his eldest son in a mournful mind placed this monument.'

## Milne/Mylne Monument (East Wall)
The monument to the south of the main entrance on the east wall is dedicated to John Milne or Mylne. It is designed in a classical fashion with Corinthian pillars. On its top is a coat of arms with cherubs supporting it at either side. The upper scroll inscription panel is held in the mouth and paws of a lion. A few green men make up part of the scrollwork. The monument is surrounded by a semicircle of railings with spearhead- and urn-shaped finals on the top. The upper inscription translates as:

> To John Milne, who at the expiry of fifty five years this frail life, sleeps softly here, sixth Master-Mason to the king of the family of Milne of remarkable skill in the building art, frequently Deacon-Conver of the Trades of Edinburgh, the circumspect and faithful representative of the metropolis on several occasions in the public Parliament of the Kingdom, a man adored with gifts of mind above his condition in life, of a remarkably handsome person, upright, sagacious, pious, universally respected.

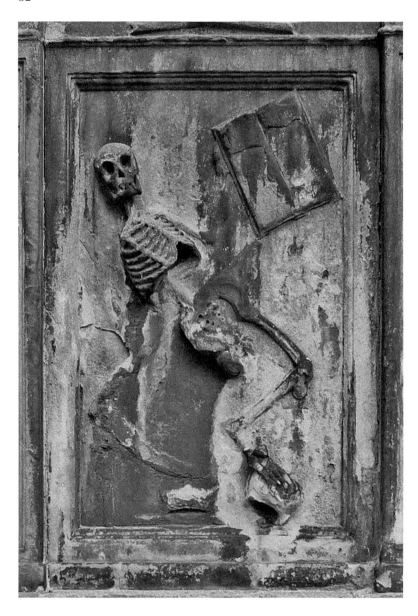

Borthwick monument on the wall of the church.

Robert, his brother's son, emulous of his virtues, as well as his successor in office, has, out of gratitude, erected this monument, such as it is, to his uncle. He died 24 Dec 1667, in the fifty-sixth year of his age.

There are four tombs within the graveyard that Robert Mylne worked on: his father's mural monument; Alexander Bethune's monument (1672), located on the east wall; the Trotters of Morton Hall (1709), which was begun by Robert Mylne and finished by his son William, located on the north wall; and James Chalmer's monument (1675), located on the upper-west wall.

*Above left*: John Milne monument.

*Above right*: Bethune monument.

*Below left*: Trotters of Morton Hall chamber, built to protect the monument.

*Below right*: Chalmers monument.

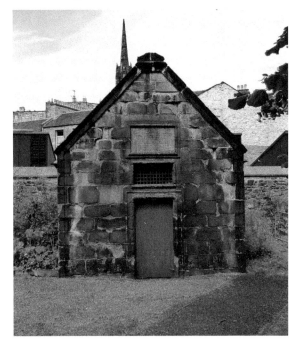

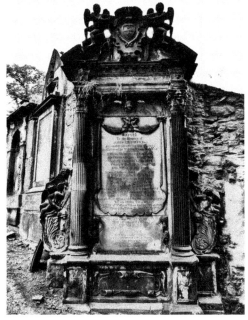

# 6. Greyfriars Bobby

No book on Greyfriars would ever be complete without including Greyfriars Bobby. Upon entering the graveyard, right in front of you near the main entrance is one of the most photographed gravestones to be found within its walls. This rather unremarkable red stone does not belong to a person, however, rather a little Skye terrier called Bobby. Greyfriars Bobby's story can be told many ways, with a myriad of people claiming beyond a shadow of a doubt that their version is the real story. Likewise, you will find people who say there was never a little dog called Bobby who sat on his master's grave, beloved by a city and the inspiration of books and films. There are even doubts on the age of Bobby and indeed how many Bobbys there were.

The most commonly known version of his story is that of Eleanor Aitkinson, which was written in 1912. Aitkinson, an American writer and teacher, never visited Edinburgh, let alone Scotland. However, her strong grasp of the local dialect of the time is remarkable and indicates that she was told the story by a person (or persons) local to the Old Town of Edinburgh. The most accepted explanation is that she not only spoke to but also spent time with Scottish immigrants, who had decided to leave the poverty of the overcrowded cities and travel to America to start afresh. Whether it was they or she who created

Greyfriars Bobby gravestone.

Bobby's master as an old shepherd who died behind the White Hart Inn (a pub that can still be visited today in the Grassmarket not far from Greyfriars), we will never know, and it is not the only instance of poetic licencing being put to work throughout the novel. That said, there are a few scenarios through the tale that are plausible. Let me attempt to give you the version I believe to be correct, through newspaper reports of the day.

On Monday 15 April 1867, in the 'Police Courts' section of the *London Daily News*, it was reported: 'A very singular and interesting occurrence was yesterday brought to light in the Burgh Court, by the hearing of a summons in regard to a dog tax.' The newspaper relays the tale that eight and a half years previously, after the death of local man John Gray, a little dog began his vigil over his master's grave.

James Brown, the sexton of the graveyard, reported that a Scotch terrier was found lying on the new grave the morning after the funeral. Although Brown tried to chase the little terrier away, time after time he would sneak back to take up his place once more. Eventually Brown softened to the dog, now known as Bobby, and in recognition to the devotion shown to his late master he relented and let him stay. Bobby chose to stay in the graveyard over the comfort of being indoors. Brown recounted that he tried on occasion to take him indoors when the weather was bad, but Bobby would howl and cry with such a pitiful tone until he was freed to return to his vigil once more. The fame of Bobby spread, gaining him friends such as Sergeant Scott of the Engineers, who would treat his furry friend to a weekly steak, and Mr Trail who owned a restaurant at No. 6 Greyfriars Place and would feed him daily, arriving promptly after the midday gun sounded. It was the good-hearted Mr Trail who was charged with harbouring a dog without paying tax. The defendant stated that he would be pleased to pay the tax if the dog had belonged to him, but as the dog refused to attach himself to anyone it was impossible to fix ownership on any one person. Upon hearing the peculiar circumstances, the court dismissed the summons.

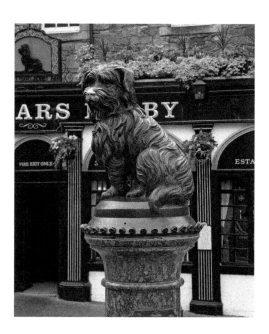

Statue of Greyfriars Bobby.

When the Lord Provost, Sir William Chambers, heard about wee Bobby's plight, rather than letting him be put to sleep as the new laws dictated for unlicensed dogs, he paid for the licence himself and presented him with a collar, on which was written on a brass plate: 'Greyfriars Bobby from the Lord Provost 1867 Licenced'. The collar can still be seen today at the Edinburgh Museum in the Canongate.

In the *Fife Herald* newspaper dated 16 November 1871, it was reported that Baroness Angela Burdett Coutts wished to commission the building of a red-granite monument adorned with a statue of Bobby, which she would pay for at her own expense. Baroness Burdett Coutts, a nineteenth-century philanthropist and patroness of the Royal Society of the Prevention of Cruelty to Animals, had heard of the story of the faithful little dog and wanted to acknowledge his devotion. Sadly, wee Bobby did not live long enough to see his monument. *The Scotsman* reported on 17 January 1872:

> Many will be sorry to hear that the poor but interesting dog 'Greyfriars Bobby' died on Sunday evening. Every kind attention was paid to him in his last days by his guardian Mr Trail, who has had him buried in a flower plot near Greyfriars Church. His collar, a gift from the Lord Provost Chambers has been deposited in the office at the Church gate. Mr Brodie has successfully modelled the figure of Greyfriars Bobby which is to be erected by the munificence of the Baroness Burdett Coutts.

The plaque on Bobby's memorial fountain reads:

<div align="center">

*A tribute*
*to the affectionate fidelity of*
*Greyfriars Bobby*
*In 1858 this faithful dog followed*
*The remains of his master to Greyfriars*
*Churchyard and lingered near the spot*
*Until his death in 1872*
*With permission*
*Erected by the*
*Baroness Burdett Coutts*

</div>

In December 1873 a 7-foot-tall fountain in memory of Greyfriars Bobby was erected at the corner of George IV Bridge and Candlemaker Row, designed so dogs could drink from the bottom and humans could drink from the top. The monument still stands today and is the most photographed statue in the city. The water was turned off many years ago and the chained cups removed, and sadly around 2012 some unscrupulous tour guides started the false rumour that it was a 'tradition' to rub the nose for luck. This is not a tradition and it is in fact damaging the statue, despite numerous attempts to repair it and stop the practice. So, please remember, *don't* rub Bobby's nose!

So far, the evidence that Bobby did exist all points to the story being true; however, newspapers (the storytellers of Bobby's tale) now have modern counterparts that share the opinion that Bobby did not exist or that there was more than one 'Bobby'.

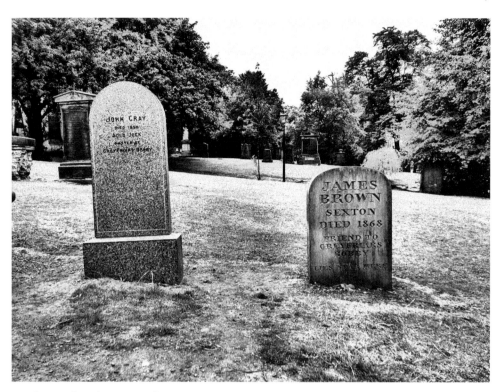

Headstones for John Gray and James Brown.

The first notion that Bobby had never existed was put about by Councillor Gillies of Edinburgh Town Council in 1889, who referred to the story of Bobby as being a 'penny-a-liners' romance' at a town council meeting to discuss a petition for a memorial to be erected within the graveyard in memory of Bobby. Evidently Councillor Gillies was not a fan of the much-loved Bobby and was instead trying to spread propaganda that the little dog had not existed to suit his own opinions on the suitability of such a structure, which he wholeheartedly thought was unsuitable. He further tried to justify his point that even if Bobby's story was true 'was it decent to put up a monument to a dog in Greyfriars Churchyard'.

Councillor Gillies would eventually lose this fight, even if it was nearly a hundred years later, when a stone was erected to Bobby's memory. It reads:

Greyfriars Bobby
Died 14th January 1872
Aged 16 Years
Let His Loyalty and Devotion
Be a Lesson to us all
Erected by the Dog Aid Society
Of Scotland and Unveiled by H/RH
The Duke of Gloucester G. C. V. O.
On 13th May 1981

A few years later a second stone was erected along the path near the east wall, this time to Bobby's master, John Gray:

John Gray
Died 1858
'Auld Jock'
Master of Greyfriars Bobby
'And even in his Ashes
Most beloved'
Erected by
American Lovers of Bobby

Finally, a third stone was erected to James Brown, the man of both Greyfriars Bobby fame and also who documented memorials in the graveyard. His stone is next to John Gray's:

James Brown
Sexton
Died 1868
Friend to Greyfriars Bobby
He lies near here.

So, that is Bobby's story through the papers. However, there is one true tradition that has not been mentioned. In the 1980s the Old Town still was home to many families, rather than students and Air BnB flats, and when a local child lost a much beloved pet they would leave the collar or toys of the beloved pet on Bobby's grave, as they would have no grave of their own in the urban area. Since then this has evolved into people leaving sticks in Bobby's memory, but once in a while the old tradition still remains and a little collar or toy can be found to a much-loved passed pet.

# 7. The Burial of a Nineteenth-century Gentleman

In the twenty-first century our funerals are rather different from those of the nineteenth century, which were filled with pomp and ceremony. The run-up to the burial day and the procession to the graveyard were the main affairs, with the actual burial itself being without much ceremony. Due to newspaper reports of the time and the documents found in the National Records of Scotland, we are able to recreate these splendid funerals in the mind's eye.

One such gentleman whose burial costs have been preserved and who was buried in Greyfriars is Thomas Smith Esq, one of the principal clerks to the bill and former city Baillie. He died on 9 March 1813 and was laid to rest in the west ground:

March 13 for his funeral in new burying ground, Greyfriars.
To a coffin with best gilt mounting £7/7/0
'an engraved Brass plate for Do £1/1/0
'fine grave clothes £5/5/0
Cash paid for warrant and poor £1/5/6
'Do for large deep grave and turf £1/5/6
'Do for 2 Mute, Household and recorder £1/13/6
'Do for 6 ushers, 6 battonmen and 4 bearers £2/1/11
'Do for Mort Cloth and delivering cards and letters £1/13/0
'Do for 14 pairs of men's gloves £1/12/6
'Do for 10 bottles of wine £2/4/0
'Do for 1 bottle Brandy and 5 Do Whiskey £1/3/0
'Do for Bread and Biscuit £1/5/0
'Do for 2 men watching Grave 6 nights £2/1/0
'Do for purchase Money of Burying Ground £70/0/0
'Do fir clerk's fees £2/0/0
£103/1/0

We are also fortunate that the estimate for the cost of the monument for Thomas Smith is also in the archives, which came to £125 19s 8d. It is interesting that the cost of the monument cost more than the funeral. Future burials (thirteen in total) would not have included the cost of the memorial, only for the inscribing of a name and details of the death. This plot when purchased was for three plots for Thomas Smith's family.

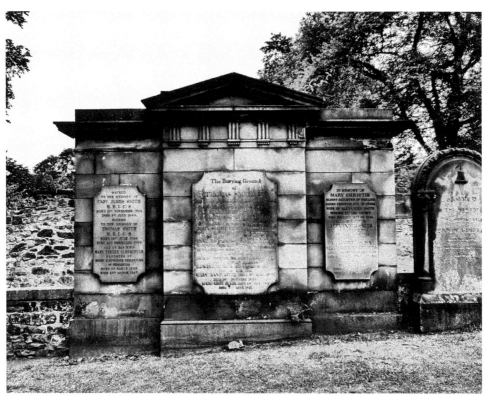

Thomas Smith monument.

## The Coffin

The coffin, the last view and final resting bed of the deceased, needed to show the occupant's place in society. A family was expected to show their respect for the deceased and would be judged by their peers on the suitability of the coffin. The use of a coffin for burial goes back to biblical days; however, in Scotland up until the Reformation many of the common people were buried without a coffin. The coffin became a status symbol: the higher in society the family was, the finer the coffin.

From the eighteenth century, the Scottish upper classes chose to improve the appearance of their coffins to further show their place in society. A name plate was always added – usually of brass, though tin would also be used – and gilded to give the impression of wealth. Further decoration, such as silver lace for an adult or white for a child, was attached to the cloth covering. In the eighteenth century coffins were made by local craftsmen, but by the nineteenth century fine cabinetmakers and upholsterers became specialist coffin makers and, in just a few short years, became part of the undertaker profession.

## Professional Funeral Attendants

There are specific roles held by men who were employed for the procession of the funeral. Their positions were conducted to ensure the funeral would be carried out in accordance to custom and tradition. In the case of Thomas Smith, he had two mutes, six ushers,

six baton men and four bearers. The attendants of the funeral are represented as the heraldic positions the attendants would hold of a past era. The mutes represented the herald-at-arms leading the procession; the baton men were representations of the knight companions-at-arms; and the ushers were the gentleman ushers.

The mute's role started out as a practical part of the funeral process in Britain. A single mute or a pair stood on the doorstep, standing silent with a solemn expression to keep the body safe until the time of burial. By the coming of the nineteenth century the mute had become a firm part of the traditional funeral procession, although the role, now a ceremonial one, was to lead the funeral procession to the graveside. The mute was identified by the sight of him carrying a staff known as a wand, swathed in silk dressing and ribbon, fixed in place with a rosette known as a love ribbon to secure the material from being blown in the breeze. The mute would wear a sash and a long piece of material that would hang down his back. Those who are familiar with the film *Oliver Twist* will recognise the dress from the scene where Oliver is sold as a mute to a funeral team before he joins Fagin's gang.

The ushers, who were also known as pages in some funeral documents, were to escort the body of the deceased from their earthly homes to the place of their final rest. They carried wands similar to the mute. They had a ceremonial role rather than a practical one, but they were considered an important part of traditional ceremony.

The baton men had a practical role in the traditional walking funeral, using their batons to clear the way for the funeral to progress. The batons were unlike the truncheons held by constables; they were, in fact, ceremonial and not for hitting people out of the way. Although the nineteenth-century horse-drawn hearses were in use the traditional walking funeral was the preferred method, especially if the burial ground was nearby. The number of bearers could vary from two to eight. Most of the bearers would be family members, so the extra numbers would be taken up by professional bearers.

In the early years of burials in Greyfriars, many of the plots were not designated, leading to arguments between families; however, the recorder's job was to record exactly where the body was interned in accordance with designated town council plots.

## Gloves

In nineteenth-century Britain it was commonplace for memorial rings or gloves to be handed out to mourners, at the expense of the family. The gloves were distributed to the mourners prior to the journey to the grave. For the funerals of children, unmarried people or women who died in childbirth the gloves would be white; for all others the gloves would be black.

## Refreshments

The lyke wake was the process of giving refreshment to the visitors before the burial. The term 'lyke' was to describe an unburied corpse; therefore the lyke wake was the continuous watch over the body until burial. Generally, the social rule was the larger and grander the household, the more elaborate the lyke wake. The purpose of the gathering was so the family and friends of the deceased could share their grief and lend support to each other. It was deemed that emotional women would be unable to control their feelings at the burial and so were excluded, especially the women of the middle and upper classes.

The hospitality shown at the wake was also judged by the peers of the deceased's family. To not provide adequate refreshments would be considered shameful as it was deemed they were not sending a loved one off in a socially acceptable manner.

## Rise of the Undertaker in the Eighteenth Century

The undertakers used by the Smith family were Bruce & Burns. The Post Office Directory for 1813 had their address as No. 27 South Bridge and they are described as upholsters. The term 'undertaker' seems to have first been used during the reign of Queen Anne (1665–1714), supplying the mourning attire and funeral gifts to the attendant of funerals of London. During the latter part of the eighteenth century the way funeral items were ordered and how the funeral was organised began to change. Previously, tradesmen were contracted individually by the family and the church played a large part of the funeral process. However, the role of the undertaker was to change this. Undertakers were usually

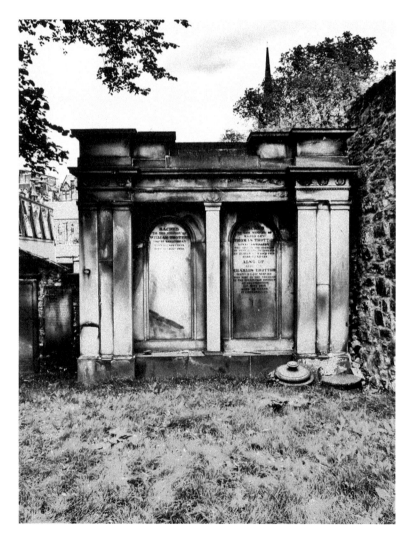

William Trotter monument.

cabinetmakers or upholsterers who began to stock all the supplies required for a funeral. In the mid-eighteenth century the process of dying became more the responsibility of the doctor rather than the church, leading the undertaker to take control of the body after the doctor's work was concluded.

Funerals often follow tradition, but as the undertaker began to take control an element of individualism began to creep in. As undertakers removed the hassle of organising a funeral from the families of the deceased, the middle and upper classes began to demand more in the way of funeral pomp and added trappings that became necessary for what was considered a good funeral. During the nineteenth century, undertakers realised there was a market to ensure the poorer classes could emulate funerals of the wealthy. They were able to offer cheaper versions of grand funerals to those who could afford it. People generally applied to the nearest undertaker, but as the profession continued to grow people were able to act on recommendations and pick one their own. It was not uncommon for a doctor to be paid up to £10 to recommend one business over another to those who were near death. By the 1800s it was the undertaker who was able to more or less pick and choose their customers. One such undertaker was William Trotter of Prince's Street, who gained such a reputation that the nobility of the city would use him over any other. He gained such popularity that he was made Lord Provost of Edinburgh 1825–26. When he died in 1833 he was laid to rest in the west yard, surrounded by many of his former clients.

# Bibliography

Anderson, W., Pitcairn, *Silences That Speak* (Edinburgh: Alexander Brunton, 1931).

Barley, Nigel, *Dancing on the Grave: Encounters with Death* (St Ives: Clays Ltd, 1995).

Boston, Ceridwen, 'Burial Practice and Material Culture' in *In the Vaults Beneath*, ed. by Ian Scott (Oxford: The Oxford Archaeological Unit Ltd, 2009).

Brown, James, *The Epitaphs and Monumental Inscriptions in Greyfriars Churchyard, Edinburgh* (Edinburgh: J. Moodie Miller, 1867).

Bryce, William Moir, *History of the Old Greyfriars' Church Edinburgh* (Edinburgh: William Green, 1912).

Cole, Hubert, *Things for the Surgeon.* (London: Heineman, 1964).

Cunnington, Phillis and Lucas, Catherine, *Costume for Births, Marriages and Deaths* (London: A. & C. Black Limited, 1972).

Davies, Douglas J., *A Brief History of Death* (Oxford: Blackwell Publishing, 2005).

Eliot, George, *Adam Bene* (Ware: Wordswoth Editions Ltd, 2005).

Fido, Martin, *Bodysnatchers, A History of the Resurrectionists* (London: Weidenfield & Nicolson Limited, 1988).

Gifford, John, McWilliams, Colin, Walker David and Wilson, Christopher, *The Buildings of Scotland: Edinburgh* (Middlesex: Penguin 1984).

Gordon, Ann, *Death is for the Living* (Edinburgh: Paul Harris Publishing, 1984).

Hancox, Emma, 'The Impediments of Death Specialist Reports, Coffins and Coffin Furniture' in *St. Martin's Uncovered*, ed. by Megan Brickley, Simon Buteux, Josephine Adams & Richard Cherrington (Oxford: Oxbow Books, 2006).

Henderson, J. A., *Black Markers* (Stroud: Amberley Publishing, 2015).

Herron, Andrew, *A Guide to the General Assembly of the Church of Scotland* (Edinburgh: The Saint Andrew Press, 1986).

Howarth, G., 'Professionalising the Funeral Industry in England 1700–1960' in *The Changing Face of Death*, ed. by P. C. Jupp and G. Howarth (Basingstoke:MacMillan, 1997).

Jalland, Pat, *Death in the Victorian Family* (Oxford: Oxford University Press 1996).

Keister, Douglas, *Stories in Stone: A Field Guide to Cemetery Symbolism and Iconography* (London: Gibbs Smith, 2004).

Kerrigan, Michael, *The History of Death: Burial Customs and Funeral Rites, from the Ancient World to Modern Times* (Guilford: Lyons Press, 2007).

Lennox, Suzie, *Bodysnatchers* (Barnsley: Pen and Sword Books, 2016).

Lévinas, Emmanuel, *God, Death and Time*, trans. by Bettina Bergo (Stanford: Stanford University Press, 2000).

Love, Dane, *Scottish Kirkyards* (Stroud: Amberley Publishing, 2010).

Mathieson, Padi, *The Greyfriars Story* (Edinburgh: The Society of Friends to Greyfriars, 2000).

May, Trevor, *The Victorian Undertaker* (Haverford: Shire Publications Ltd, 1996).

Morley, John, *Death, Heaven and the Victorians* (London: Studio Vista, 1971).

Penny, Nicholas, *Mourning: The Arts and Living* (Wisbech: Balding and Mansell, 1981).

Puckle, Bertram S., *Funeral Customs* (London: T. Werner Laurie Ltd, 1926).

Quigley, Christine, *The Corpse: A History* (Jefferson: McFarland & Co. Inc, 1996).

Richardson, Ruth, *Death, Dissection, and the Destitute* (London: Phoenix Press, 2001).

Rickards, Maurice, *Encyclopaedia of Ephemera* (London: Routledge, 2001).

Sanderson, Elizabeth C., *Woman and Work in Eighteenth Century Edinburgh* (London: MacMillan Press Ltd, 1996).

Smith, Michael, *The Secularization of Death in Scotland, 1815–1900* (New York: The Edwin Mellen Press, 2014).

Spinoza, Jorge, *The Encyclopedia of Death and Dying* (New York: Facts on File Inc, 2005).

Steedman, Carolyn, *An Everyday Life of the English Working Class: Work, Self and Sociability in the Early Nineteenth Century* (Cambridge: Cambridge University Press, 2013).

Stone, Elizabeth, *God's Acre: Or Historical Notices Relating to Churchyards* (London: John W. Parker and Son, 1858).

Tarlow, Sarah, *Ritual, Belief and the Dead in Early Modern Britain and Ireland* (Cambridge: Cambridge University Press, 2010).

Wheeler, Michael, *Heaven, Hell and the Victorians* (Cambridge: Cambridge University Press, 1990).

Willsher, Betty, *Understanding Scottish Graveyards* (Trowbridge: The Cromwell Press, 1995).

Wood, Claire, *Dickens and the Business of Death* (Cambridge: Cambridge University Press, 2015).

Womersley, Tara and Crawford, Dorothy H., *Bodysnatchers to Lifesavers* (Edinburgh: Luath Press Ltd, 2010).

# Acknowledgements

My heartfelt thanks go to Jan Andrew Henderson. Without his encouragement, guidance and friendship this book would never have been written. Special thanks goes to my amazing husband and son, Jamie and Brandon, whose love and support (and the delivery of glasses of wine) has been priceless, and I couldn't have written this without them. Likewise, I want to express my gratitude and love to my parents, Sue and Dave, for encouraging my love of reading from an early age and being my first teachers, providing me with a love of learning.

There are also a few others I want to thank. The team at Amberley, especially Becky Cousins, Nick Grant and Jenny Stephens. Also, Archie, Barb, Emily, Fred, Norrie, Sonia and my wonderful friends for their input, the staff at the National Records of Scotland and the staff and volunteers at Greyfriars Kirk. Parts of this book would not have been possible without Thomas Smith Esq and his descendant William Cuninghame of Caprington, of the Smith Cuninghame family, whose preservation of important documents ensure history is kept alive. And thank you dear reader for sharing in my passion for such a beautiful graveyard.